POSTCARD HISTORY SERIES

Madison County
Kentucky

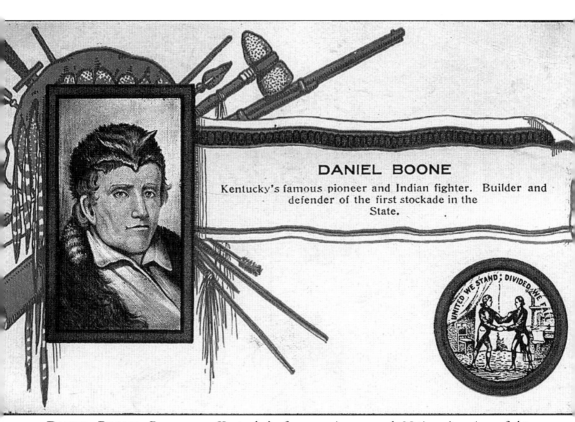

DANIEL BOONE

Kentucky's famous pioneer and Indian fighter. Builder and defender of the first stockade in the State.

DANIEL BOONE. Boone was Kentucky's famous pioneer and Native American fighter. He helped build and was a defender of the first permanent stockade (Fort Boonesborough) in Kentucky.

Front Cover: **MADISON TOBACCO WAREHOUSE.** A group of farmers are pictured gathered on crop-selling day at Madison Tobacco Warehouse, Richmond, Kentucky (*c.* 1920). Notice that they are dressed in suits and ties and there is one lady present, too.

Back Cover: **GLYNDON HOTEL.** The Glyndon Hotel on Main Street in Richmond, Kentucky, welcomed guests from across the state and nation. It was mid-way between the railroad stations in Richmond at the early part of the 20th century—the L&N Station on East Main Street and the Riney-B Station on North Third Street. A mule-drawn trolley took passengers from both to the hotel. One guest came in style in the 1921 Pearce Arrow shown parked in front.

POSTCARD HISTORY SERIES

Madison County
Kentucky

Harry C. Johnson

ARCADIA

Copyright © 2004 by Harry C. Johnson
ISBN 0-7385-1688-0

First published 2004
Reprinted 2005

Published by Arcadia Publishing
Charleston SC, Chicago IL, Portsmouth NH, San Francisco CA

Printed in Great Britain

Library of Congress Catalog Card Number: 2004107311

For all general information contact Arcadia Publishing at:
Telephone 843-853-2070
Fax 843-853-0044
E-mail sales@arcadiapublishing.com
For customer service and orders:
Toll-Free 1-888-313-2665

Visit us on the internet at http://www.arcadiapublishing.com

"WISH YOU WERE HERE"

Picture postcards bring to mind someone in a faraway place saying "wish you were here." However, picture postcards from a century ago served another purpose. They were a means of communication for holidays, birthdays, get well, sympathy, and other occasions. Some businesses also used them for advertisements. They were a very economical means of communication; postage was only 1¢.

This book uses postcards that depict Main Street and various older buildings no longer standing. It was common for many local businesses, especially drug stores, to have a photo taken and to have a postcard made from the negative. Many postcards were printed in Germany because of their skills in lithography. World War I caused a halt to this practice, and as a result, some American publishers came on the scene.

What is their value today? Much value, of course, is found in the nostalgia of looking back to "the good old days" of family or hometown businesses. They have also proved vital in restoration projects. A building facade could be closely restored to its original state because the designer could see how the structure looked a century ago.

CONTENTS

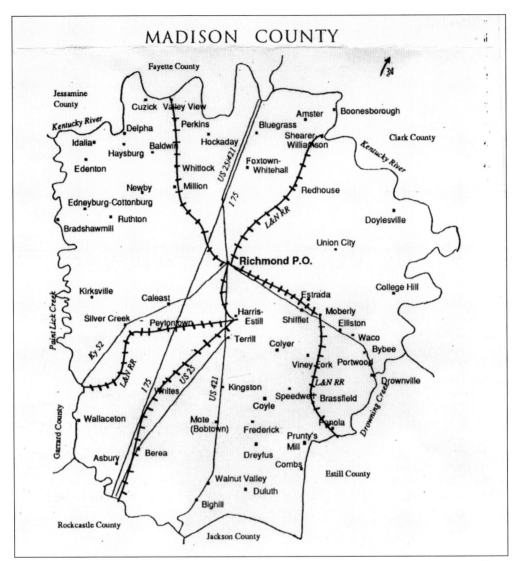

MADISON COUNTY. This map depicts some of the early towns and villages that had post offices. The RNIB Railroad (Riney-B) route is shown entering Valley View from Jessamine County and going through Richmond, Moberly, Brassfield, and Panola and on to Estill County. The Louisville and Nashville Railroad (L&N) came from Clark County and went through Richmond and Berea before exiting through the tunnel at Boone's Gap into Rockcastle County. There was also a Rowland Branch of the L&N that ran from Lancaster to Paint Lick and Silver Creek to Fort Estill. A noted locomotive on this line was the *Old Henry*.

ACKNOWLEDGMENTS

It is with sincere gratitude that I express my thanks and appreciation to:

Our Heavenly Father and His Son, the Lord Jesus Christ, for grace and strength to complete this project in spite of physical impairments.

My wife Lillie for her forbearance and understanding while I was working on this publication.

Bill Feldman of Frankfort for his invaluable help in scanning the postcards.

Charles Hay III of the Madison County Historical Society for his editorial assistance.

Ron Morgan of Frankfort and Peggy Brown of Lexington for use of their postcards.

J.T. Sowders of Richmond for his technical assistance.

Carroll Hackworth and David Green for research in identifying the location of the Catholic Mission House (page 43).

Rochelle Stidham (publisher) and Nancy Taggart (photographer), both of the *Richmond Register,* for their technical assistance.

Marc Whitt for permission to use postcards of Eastern Kentucky University.

Jackie Couture, Special Collections, Eastern Kentucky University, for technical assistance.

Bob Johnson for his expertise in identifying vintage autos.

REFERENCES

Dorris, Jonathan Truman. *Five Decades of Progress: Eastern Kentucky State College, 1906–1956.* Richmond, KY: State College Press, 1957.

Dorris, Jonathan T. & Dorris, Maud Weaver. *Glimpses of Historic Madison County, Kentucky.* Nashville, TN: Williams Printing Company, 1955.

Ellis, William, Everman, H.E., and Sears, Richard. *Madison County: 200 Years in Retrospect.* Madison County, KY: Madison County Historical Society, 1986.

Engle, Fred and Grise, Robert. *Madison's Heritage.* Richmond, Kentucky: self published, 1985.

Kubiak, Lavinia H. *Madison County Rediscovered: Selected Historic Architecture.* Madison, KY: Madison County Historical Society, 1988.

Peck, Elisabeth S. *Berea's First 125 Years, 1855–1980.* Lexington, KY: University Press of Kentucky, 1982.

Rennick, Robert M. *Kentucky's Bluegrass: A Survey of the Post Offices.* Lake Grove, OR: The Depot, 1993.

INTRODUCTION

Madison County was formed in 1786, six years before Kentucky achieved statehood. Patrick Henry, the governor of Virginia, signed a bill creating the county, and it was named for James Madison, who later became the fourth president of the United States. Madison County was formed by territory taken from Lincoln County, one of the three original counties of the Kentucky territory of Virginia (along with Fayette and Jefferson). Since then the county has undergone many changes, including having its territory taken in order to form new counties. The last change was made in 1821. With an area of 450 square miles, Madison County ranks 22nd in size in Kentucky. The latest census figures show a total population of 67,600, including 27,600 in Richmond and 10,000 in Berea. The county's population has doubled in the last 20 years.

Richmond, the county seat, is also connected to Virginia because it was named after John Miller's home in Richmond, Virginia. It was not, however, the first county seat. The first was actually at Milford, a settlement where a temporary courthouse was built. A more permanent building of stone and wood was constructed in 1788. Milford was not favorable for a county seat, and in 1798 the state authorities authorized the Madison County Court to transact business elsewhere. The court chose John Miller's barn and secretly moved the records there. Fist fights ensued after the move. Milford citizens were compensated $1,600 for losses due to the removal of the seat of government.

Madison County was a typical rural community with two "big" cities, Richmond and Berea. However, every village usually had a general store, a post office (usually inside the general store), a one- or two-room schoolhouse, and a Baptist church somewhere nearby. Post offices have had a radical change in that only 4 (Richmond, Berea, Waco and Big Hill) are left of the approximately 70 locations of the past century. The era of the small schoolhouse has also gone its way, and today the Madison County School system contains six elementary schools, three middle schools, and two high schools. Baptist churches predominate, but many other denominations are also represented.

The Kentucky River, which forms over 62 miles (one-half of its circumference) of the boundary of Madison County, has affected modes of travel. There were ferries, such as Clay's Ferry, Boonesborough, and Valley View. The ferries at Clays Ferry and Boonesborough gave way to highway bridges, but Valley View Ferry still exists. A railroad bridge is over the Kentucky River entering Madison County from Ford in Clark County, with the L&N passing through Richmond and Berea and exiting into Rockcastle County at Boone. The Riney-B Railroad also had a bridge at Valley View; its piers are still visible today. Although the L&N line ran from Cincinnati south through Atlanta and into Florida, it never had a bridge with rail traffic to Lexington. Therefore, highways to accommodate cars and trucks became necessary. Until 1946 the old bridge at Clay's Ferry, accessible by winding curves through both Madison and Fayette

Counties, carried the brunt of the load. During World War II, security was posted there due to its proximity to the Blue Grass Ordnance Depot in Madison County. Security was also posted at tunnels at both exits of the railroads into Madison County. To ride the train to Washington, D.C., it was necessary to drive by car to Lexington and catch the Chesapeake & Ohio (C&O).

Two of Kentucky's governors, James B. McCreary and Keen Johnson, have come from Madison County. A few Madison County natives have also become governors of other states, such as William J. Stone (Missouri), David R. Francis (Missouri), and Green Clay Smith (Montana Territory). Another Madison Countian, Christopher "Kit" Carson, distinguished himself as a famous Western pioneer scout. The capital of Nevada, Carson City, was named after him.

Earle B. Combs first played on the baseball team of the Eastern Kentucky State Normal School in 1919 and then played with the Louisville Colonels. He eventually went on to play with the New York Yankees alongside Babe Ruth and Lou Gehrig. Combs became the first native Kentuckian to be honored with an induction into baseball's Hall of Fame.

During World War II, Madison County sent many of her sons to the four corners of the globe in military service. With the construction of the Blue Grass Ordnance Depot, the labor force extended out to many surrounding counties to process the storage and shipment of vital supplies and munitions for the troops. Unfortunately, canisters of nerve agents have been stored there since the war and with age have become a liability to the county as well as the whole country. A plan to incinerate the nerve agents was vigorously fought by local citizens and a new process is being developed for destruction.

With the exodus of so many young men into military service during World War II, college enrollment took a nose dive. To utilize the college campus facilities, both Berea College and Eastern Kentucky Teachers College became homes for military schools. Berea College housed U.S. Navy V-12 students at Blue Ridge Hall and W.A.A.C. Detachment Br. No. 6 resided at Eastern's Burnam Hall, a ladies' dormitory.

Tobacco has been a major money crop for years. In the 1930s horse-drawn wagons could be seen lined up early in the morning to have the crop unloaded at the warehouses, but this scene is history now. The advent of trucks and the different ways of marketing and selling the crop made the unloading ramps alongside the warehouse idle. A line of these unused ramps is still visible on Altamont Street.

Hemp-growing was encouraged in the 1940s by the federal government. Hemp was vital in the manufacture of ropes that were used on naval vessels.

Sports in Richmond have reached some outstanding pinnacles. The Eastern Kentucky University Colonel football team achieved national honors by winning the NCAA Division 1-A Championship twice, in both 1979 and 1982. In 1980 and 1981 they reached the national finals. Coach Roy Kidd, a star quarterback at EKU in the 1950s, coached for 44 years (including 38 years EKU). In 2001 he attained his 300th victory in NCAA competition. He is only the seventh coach to amass that number in the NCAA and only the third (with Joe Paterno and Eddie Robinson) to win 300 at one school. The football field at Hanger Stadium has been named Roy Kidd Field in his honor.

In 1981 the Madison Central Indians baseball squad, coached by Don Richardson, attained national recognition. Competing in the boys' high school state playoffs, the Indians completed a 40-0 season with a 9-0 win over Pleasure Ridge Park. They were voted the number one high school team in the United States, the first time that that honor had been bestowed on a high school team in Kentucky.

In high school basketball play, Coach Ray Vencill took his Madison High School Royal Purples to the Kentucky State Boys Basketball Tournament in 1970, but they were defeated in the finals by the Louisville Male in a 70-69 thriller.

In 1853, Cassius Clay, a large landowner in Madison County, sought to build a community in the glade in the southern part of Madison County. He planned to use the community as a base

for his own high political ambitions and the abolitionist cause. He sold land to prominent non-slaveholders at a nominal cost and encouraged abolitionist missionaries to come to the area. In 1853, Clay offered his friend, the Reverend John G. Fee of Lewis County, a free tract of land to move to the Glade. In 1854 Fee accepted 10 acres on a ridge. With the help of local supporters and other missionaries, Fee established a church, a school, and a tiny village. When asked by Clay to name the new settlement, Fee called it Berea after the Biblical town where the people "received the Word with all readiness of mind" (Acts 17:10). Prominent Madison slaveholders drove Fee and 94 other supporters from the state in late 1859 and early 1860. After the Civil War, Fee and some other exiles returned to Berea to reestablish their dream of an interracial school and community. By 1889 the total enrollment was approximately 450 students in primary, secondary, and college departments. In 1904 the Kentucky Legislature passed the Day Law forbidding interracial schools. Students from Appalachia were recruited by the college to fill the void left by the departure of the black students. The law was repealed in 1950.

The Battle of Richmond on August 30, 1862, was the most decisive victory for the Confederate Army in Kentucky during the Civil War. In 1999 when a development company bought Battlefield Farm, located on Phase One of this battle, area residents became concerned about the preservation of the Richmond Battlefield. The Civil War Preservation Trust in Washington D.C., which designated the area as one of the top 10 most endangered battlefields in the nation, also became concerned. The Battle of Richmond Association, a partnership between the Richmond Chamber of Commerce, Madison County Historical Society, Madison County Civil War Roundtable, Blue Grass Army Depot, and Richmond and Berea businesses and officials, was created in response. The association generated even more public interest, making possible the acquisition of historic lands from private owners. A visitors' center, museum, and battlefield park are planned.

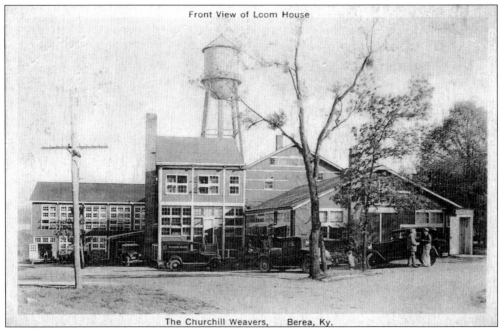

CHURCHILL WEAVERS. The Churchill Weavers was founded in Berea in 1922 by David Carroll and Eleanor Churchill. Eleanor designed and wove the fabrics while her husband designed and built the looms. Together they created what has become the foremost hand-weaving operation in the United States. Richard and Lila Bellando operate the business today.

One
MADISON COUNTY

Madison County was a quiet rural community of towns and villages until the 1940s, when three things precipitated a drastic change. First, about 15,000 acres of the county's finest farmland were converted by the U.S. Government into the Blue Grass Ordnance Depot as an arsenal for military weapons. Secondly, World War II took many of the young men into military service to the four corners of the globe, and other family members found employment in defense plants outside of the county. Lastly, Eastern Kentucky Teachers College became a faculty and student body of various nationalities and cultures. Madison County became international.

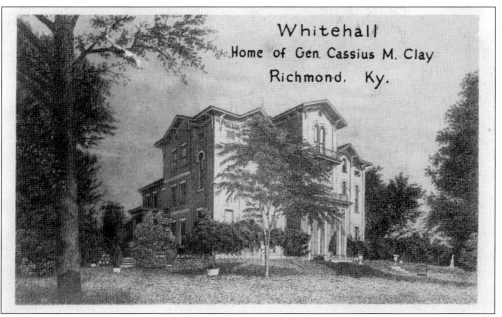

WHITE HALL. Cassius S. Clay, the son of Green Clay, a prominent land owner in Madison County lived in this home, formerly named Clermont. An ambassador to Russia when Alaska was purchased in 1867, Cassius was also a noted abolitionist closely associated with John Fee and Berea College. The home was dedicated as a Kentucky State Shrine on September 16, 1971. The project was spearheaded by Mrs. Louie (Beula) Nunn, the wife of the governor of Kentucky.

KINGSTON. This is a typical "generic" postcard that was printed in large quantities. Specific towns and states could request small orders of postcards with their names printed on the cards.

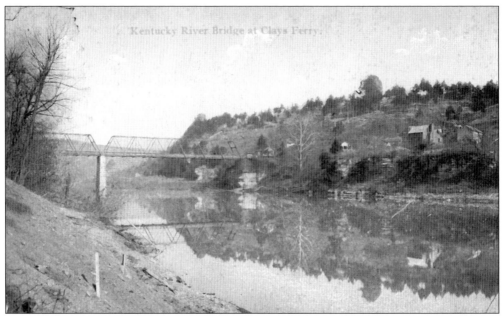

KENTUCKY RIVER BRIDGE AT CLAY'S FERRY. The old iron bridge was built in 1871 to replace a ferry between Madison and Fayette Counties. Originally a toll bridge, it was declared toll-free in 1930 after 59 years of service. North-south traffic on U.S. 25 used this route to span the Kentucky River until 1946, when the new bridge was built. This bridge is still in use for local traffic as well as for sightseeing the palisades.

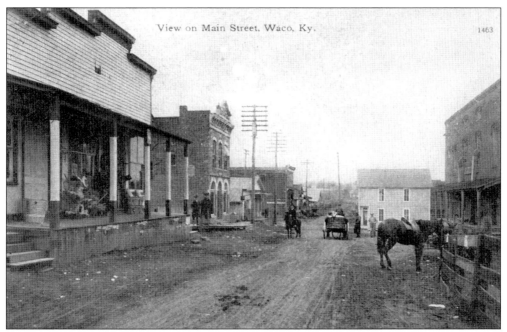

WACO. This image depicts a typical main street scene when horses and wagons were the means of transportation. The Waco Deposit Bank is the building on the left with the rounded windows.

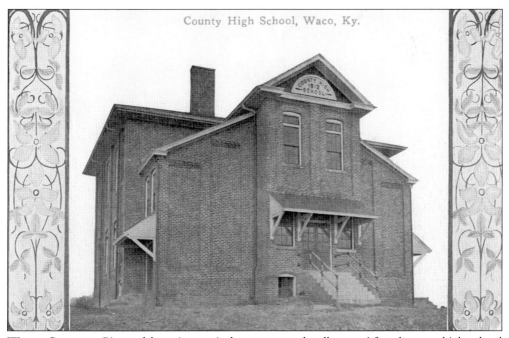

County High School, Waco, Ky.

WACO SCHOOL. Pictured here is a typical two-story schoolhouse. After the new high school building was erected, this became an elementary school. It has since been replaced by a modern structure, a complex now known as Waco Elementary School in the Madison County School system.

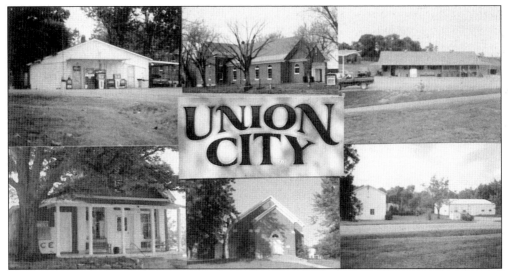

UNION CITY. This postcard shows the Union City Cash Store (established 1950), the Union City Baptist Church (established 1812, built 1848), the Union City Grocery (established 1984), Tribble Grocery & Grill (built 1830), the Union City Christian Church (established 1830, built 1894), J.D. Hamilton Lodge (established 1876), and the Union City Ruritan (established 1971). (Photo by Tim Jones.)

Greetings from ROGERSVILLE, KY.

ROGERSVILLE. This generic landscape series was utilized by this small village to make itself known.

GREETINGS FROM PANOLA, KENTUCKY.
Panola boasted a railroad depot on the Riney-B Railroad and also had a post office. This particular card was postmarked in 1910.

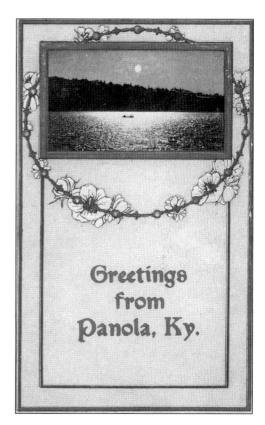

C.W. WHITTAKER & SONS. This store was built about 1904 and served the area around Cottonburg until it was destroyed by a tornado on April 3, 1974. Sons Nelson and Neal B. operated the store after the death of their father.

MOBERLY. The publisher of this postcard, postmarked in 1913, used a romantic theme.

BRASSFIELD. This card, postmarked in 1914, also had a romantic motif.

16

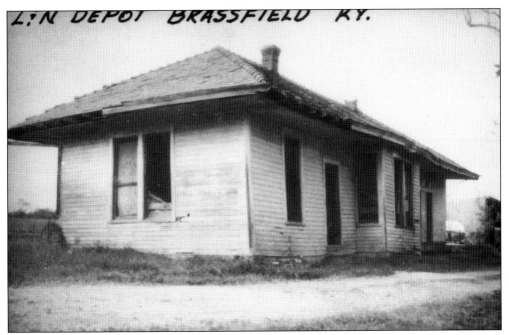

BRASSFIELD DEPOT. The Brassfield station on the Riney-B Railroad has deteriorated. Its remaining structure has fallen into use as a storage shed for farming implements.

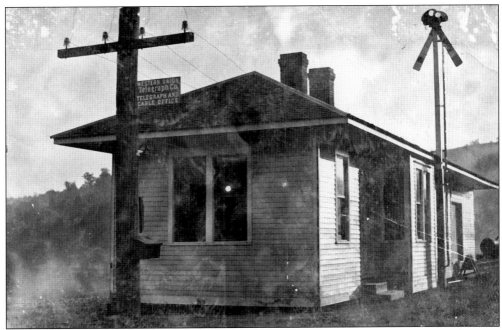

MOBERLY DEPOT. The Moberly station on the Riney-B Railroad has been long gone and is but a faint memory to the old-timers. It had a Western Union Company Telegraph and Cable Office. This card was postmarked in 1910.

GREETINGS FROM SILVER CREEK. Postmarked in 1907, this generic card shows children playing together. With a depot on the Rowland Branch of the L&N railroad, Silver Creek had a post office and distilleries.

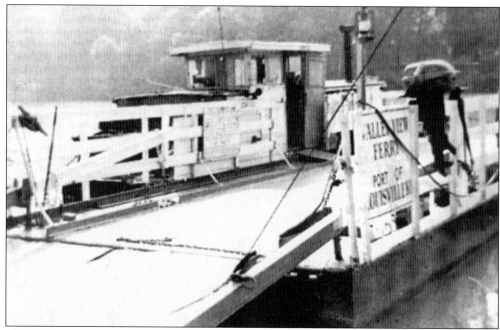

VALLEY VIEW FERRY. On the Kentucky River, it is still operating as the oldest continually operating business in Kentucky. It can be traced to 1785 (Kentucky was not granted statehood until 1792) when John Craig established a ferry. Now operated by Madison, Jessamine, and Fayette Counties, the ferry boat still carries the name *John Craig*.

BIG HILL. This postcard was lithographed in Germany. Most of the colorful cards of this era were made in Germany because of their superior workmanship. World War I put a halt to small villages importing this type of card. This one was postmarked in 1906.

Greetings
from
Big Hill, Ky.

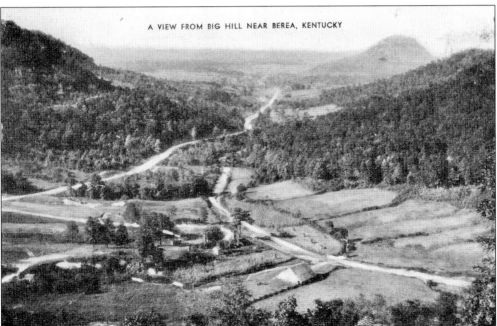

A VIEW FROM BIG HILL NEAR BEREA, KENTUCKY

BIG HILL. The Confederates saw this view as they advanced northward on August 29, 1862, the day before the Battle of Richmond. With the growth of trees and the rerouting of the highway, this beautiful panoramic scene of the valley from atop Big Hill became hidden. This card was postmarked in 1935.

19

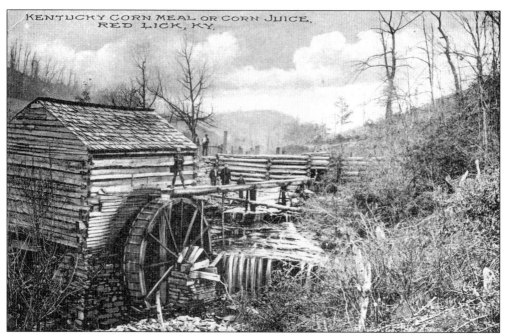

KENTUCKY CORN MEAL OR CORN JUICE,
RED LICK, KY.

RED LICK. Also known as Duluth, this area had a mill to produce corn meal or corn juice. This card was postmarked in 1912.

SPECIMEN OFFERINGS
BY THE
Madison County Fair Association
FAIR GROUNDS-RICHMOND, KY.
JULY 20, 21, 22 AND 23, 1910.
WITHOUT ENTRANCE OR DEDUCTIONS

Saddle Stallion, Mare or Gelding any age$200 00

Harness Stallion, Mare or Gelding, any age 100 00

Saddle Stallion, Mare or Gelding, 3 years old or under......... 100 00

Roadster Stallion, Mare or Gelding, any age$100 00

Foals of 1910, either sex......... 100 00

Plantation Saddle Horses 100 00

CHAMPIONSHIP--5 Per Cent to Nominate; 5 Per Cent Deducted.
Saddle Stallion, Mare or Gelding, any age - $500
$2,000 in Liberal Class Premiums for Horses, Mules and Jacks. No Entrance. No Deductions

MADISON COUNTY FAIR ASSOCIATION. Depicted here are specimen offerings at the Fair Grounds in Richmond on July 20-23, 1910.

BOONESBOROUGH TABLET. This stone was erected in memory of Daniel Boone's fort and the men, women, and children who were with him in the old fort and helped him fight the Native Americans.

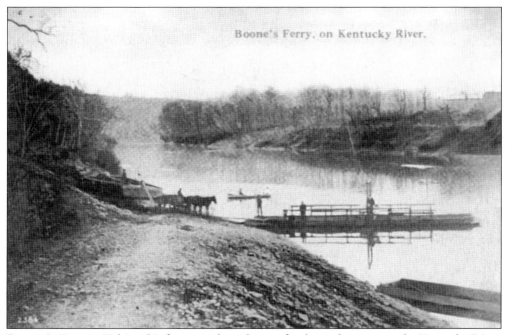

BOONE'S FERRY. Taking this ferry was the only way for the settlers to cross the Kentucky River between Madison and Clark Counties.

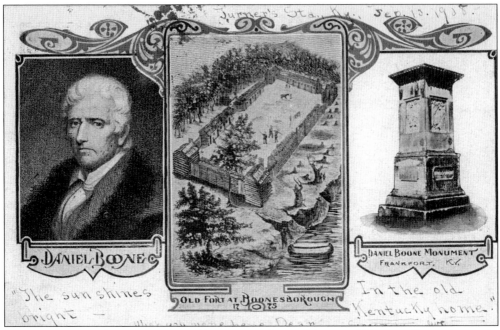

DANIEL BOONE. This three-view card has images of Daniel Boone; Old Fort at Boonesborough; and the Daniel Boone monument at the Frankfort, Kentucky cemetery..

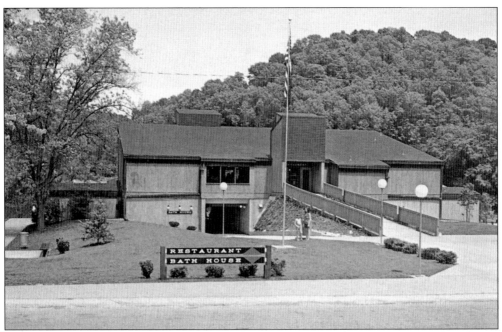

FORT BOONESBOROUGH STATE PARK. This card depicts the restaurant and bathhouse at Fort Boonesborough State Park on the Kentucky River. The bathhouse was constructed while swimming was still permitted on the sandy beach of the Kentucky River; the beach can now only be used for sunbathing. A swimming pool with a waterslide, misty fountain, children's area, and rain tree have now been added.

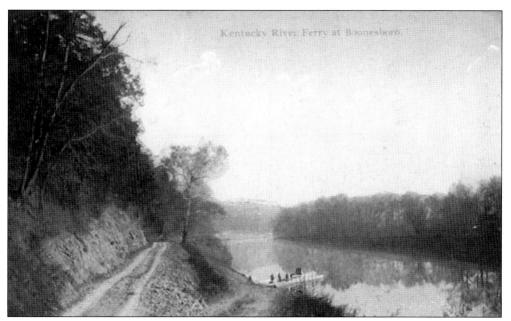

KENTUCKY RIVER FERRY AT BOONESBORO. Shown here is a scene from 1909 depicting the Kentucky River and the ferry at Boonesboro.

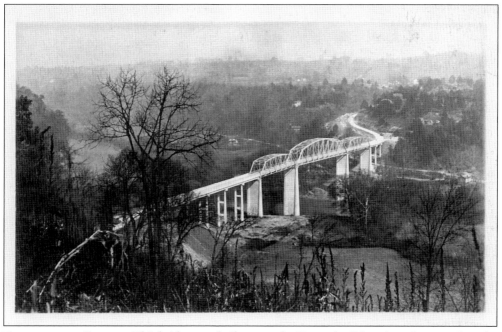

BOONESBORO BRIDGE. This bridge was built across the Kentucky River in order to replace the ferry. Because it was too narrow for modern motor vehicles, that bridge was later replaced by a wider, more modern bridge.

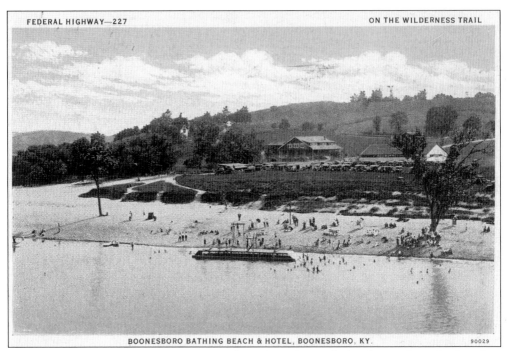

BOONESBORO BATHING BEACH & HOTEL, BOONESBORO, KY. 90029

BOONESBORO BEACH AND HOTEL. For a long time, this sandy beach was the gathering place for swimmers and picnickers from all over Central Kentucky. After the beach was declared unsafe, a swimming pool was built at the park. The card shown here was postmarked in 1939.

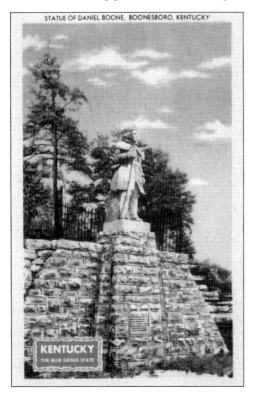

STATUE OF DANIEL BOONE, BOONESBORO, KENTUCKY

KENTUCKY
THE BLUE GRASS STATE

DANIEL BOONE STATUE. This statue was erected at Boonesboro, Kentucky, to honor the builder of the stockade and fort in 1775. Its location was in the path of the new bridge across the Kentucky River; it was removed and is now in Winchester, Kentucky.

24

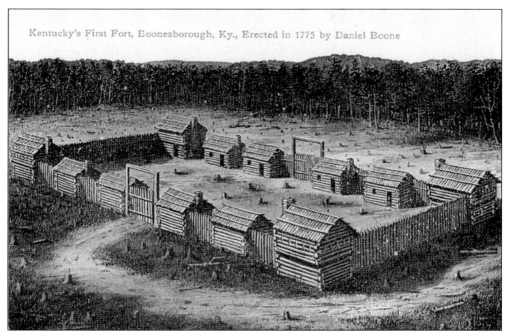

Kentucky's First Fort, Boonesborough, Ky., Erected in 1775 by Daniel Boone

FIRST KENTUCKY FORT. This fort was erected by Daniel Boone in 1775 near the Kentucky River. A replica of the old fort was built, and this area is now known as Fort Boonesborough State Park.

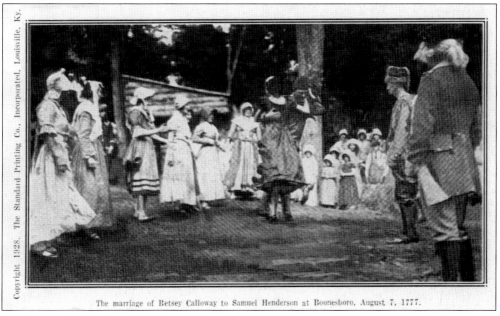

The marriage of Betsey Calloway to Samuel Henderson at Boonesboro, August 7, 1777.

CALLOWAY-HENDERSON MARRIAGE. Betsy Calloway married Samuel Henderson in Boonesboro on August 7, 1777. The ceremony was performed by Squire Boone, a brother of Daniel Boone.

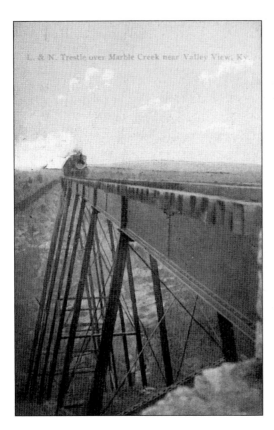

RNIB Railroad. A trestle was located near Valley View on the Kentucky River. Here, a Riney-B Railroad train nears Madison County, which had stations at Richmond, Moberly, Brassfield, and Panola, before going on to Irvine and Beattyville.

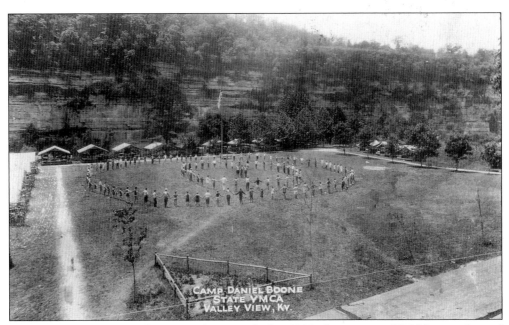

Camp Daniel Boone. This postcard, postmarked in 1939, shows a state YMCA camp located near Valley View.

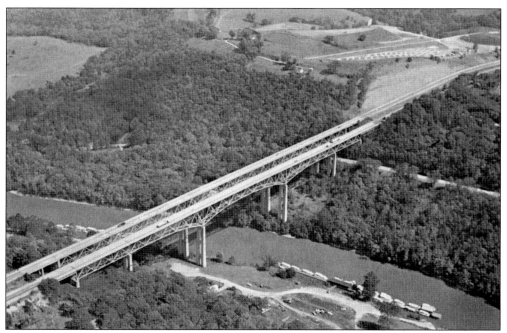

CLAY'S FERRY BRIDGE. The Clay's Ferry Bridge, originally built in 1871, was later replaced in 1946 by the Memorial Bridge (shown above), which was dedicated to those who died in World War II. With a length of 1,736 feet, it is the highest continuous steel deck bridge in the United States. Now a part of Interstate 75, is has been widened to six lanes.

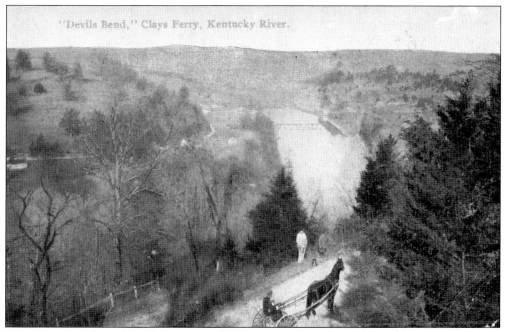

DEVIL'S BEND. It was necessary for through traffic to use this dangerous curve on U.S. 25 on the Madison County side until the new span was opened in 1946. It is still used, however, by local citizens and by those taking the scenic route over the Kentucky River.

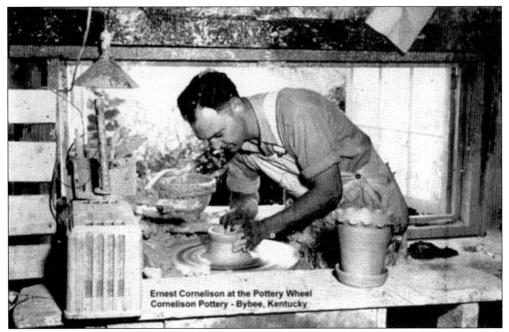

Ernest Cornelison at the Pottery Wheel
Cornelison Pottery - Bybee, Kentucky

BYBEE POTTERY. The business located east of Richmond at Bybee was established in 1845 (some claim 1809) and has been in the Cornelison family for five generations (Webster, James Eli, Walter, Ernest [in photo] and the present owner, Walter.) It ranks next to the Valley View Ferry as Madison County's oldest enterprise. The original log building houses the pottery equipment. Bybee products are in demand and are sold internationally.

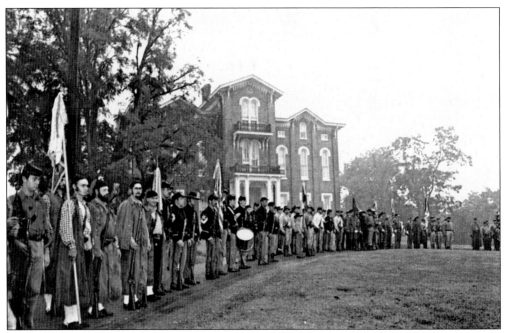

WHITE HALL STATE SHRINE. Shown here is a scene of a reenactment of the Battle of Richmond on the grounds of White Hall State Shrine.

Two
RICHMOND

A half-century ago, Richmond was the retail center for a close-knit community of farmers and livestock dealers and was a typical rural county seat town. Since then industry has settled and has provided a higher quality of life for residents without their having to go elsewhere to find employment. City government has provided a recreational and sports complex at Gibson Bay that includes a golf course, facilities for baseball and soccer, and picnicking areas for families and organizations. The E.C. Million Memorial Park, a privately-endowed nature park, is also a much-used asset. A revitalization project in 1992 has provided a new look to Main Street with colonial-type streetlights and no overhead wires. The growth in population has been phenomenal. In 1980, Richmond ranked 11th in population in the commonwealth, but by 2002, it had climbed to 7th place with an increase of over 6,300 people.

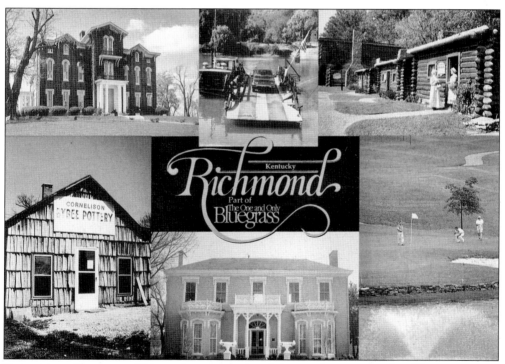

RICHMOND TOURISM. This card portrays six of the scenic areas nearby. These areas are, clockwise from upper left, as follows: White Hall State Shrine (home of Cassius Clay), Valley View Ferry, Fort Boonesborough State Park, Gibson Bay Golf Course, Irvington (Trachoma Hospital), and Cornelison's Bybee Pottery.

Well, here I am in

Richmond Ky.

Enjoying its sights and cheer;
Everything's great
and I'm feeling first rate,
But, O, how I wish you were here!

RICHMOND GREETING CARD. This card, postmarked in 1911, is a typical "wish you were here" greeting card that was sent back to a relative or friend to let him know of a safe arrival.

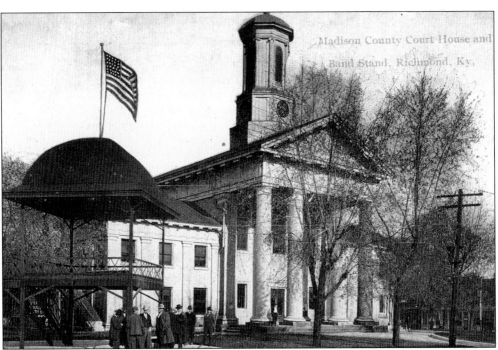

MADISON COUNTY COURTHOUSE. Built in 1849, the Madison County Courthouse has been more than a depository for deeds and other important official records. Its fence enclosed Union prisoners during the Battle of Richmond and was later moved around the Richmond Cemetery. Today it is a very significant landmark. This card was postmarked in 1914.

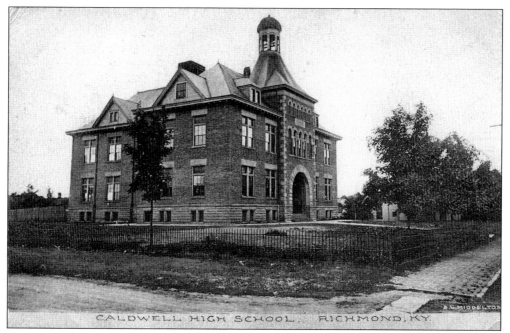

CALDWELL HIGH SCHOOL. This building was a public school until it was torched by an arsonist in 1921. The lot at the corner of North Second Street and Moberly Avenue lay vacant until 1940 when a new armory was built. It is now a part of the Richmond Parks and Recreation Department.

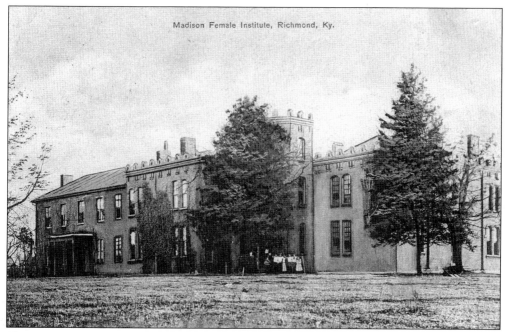

Madison Female Institute, Richmond, Ky.

MADISON FEMALE INSTITUTE. The institute was founded in 1858 as a finishing school for girls. After Caldwell High School was destroyed by arson, this location became the site for Madison High School. It is now Madison Middle School. This particular card was postmarked in 1910.

31

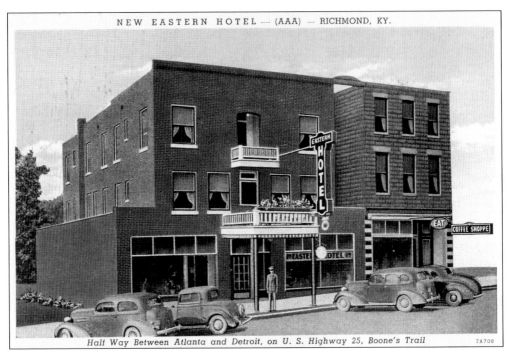

Half Way Between Atlanta and Detroit, on U. S. Highway 25, Boone's Trail

7A708

NEW EASTERN HOTEL. This building, located on East Main Street, was razed in 1977 to make room for the printing plant of *The Richmond Register*. Due to space limitations for handicapped requirements, the newspaper later moved to 380 Big Hill Avenue. The cars shown here include a 1936 Chevrolet, 1935 and 1931 Fords, and a 1937 Chrysler.

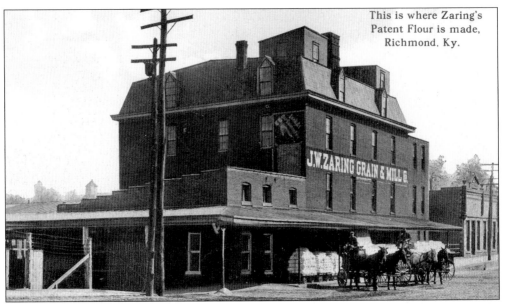

This is where Zaring's Patent Flour is made, Richmond, Ky.

ZARING'S MILL. This mill was in operation at 255 East Main Street from 1892 until 1953, when it was demolished. It was replaced by a Kroger Supermarket, which was destroyed by fire in 1967. Kroger was then rebuilt; an addition was added for SuperX Drugs. Now, CVS Drugs and Family Dollar Store occupy the site. The Kroger store has relocated to the Richmond Plaza.

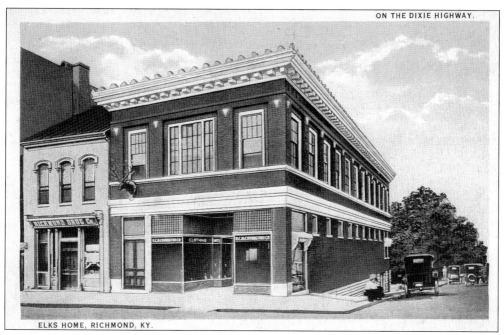

ELKS HOME, RICHMOND, KY.

BENEVOLENT AND PROTECTIVE ORDER OF ELKS LODGE. Elks have used the upper story and leased the ground floor to retail tenants, including R.C.H. Covington, United Department Store, Newberry's, and now Currier's Music World. The cars shown here are a 1915 Ford Model T and a 1916 Plymouth.

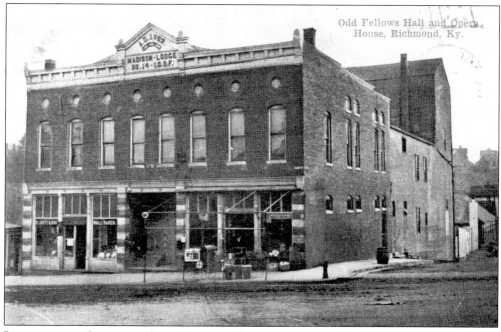

Odd Fellows Hall and Opera House, Richmond, Ky.

INDEPENDENT ORDER OF ODD FELLOWS HALL AND OPERA HOUSE. The Odd Fellows Hall, built in 1904 at the corner of Main Street and Madison Avenue, was a casualty of the 1967 fire. A U.S. bank now occupies the location. This card was postmarked in 1912.

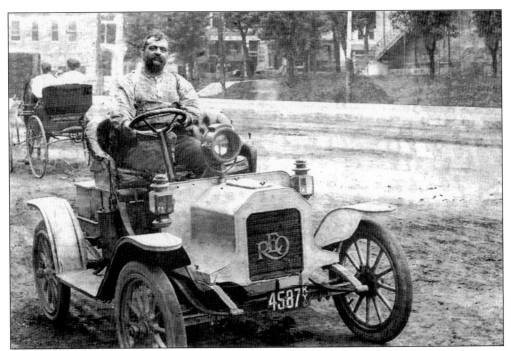

REO. Shown here is a proud owner of an REO, driven on First Street alongside the Madison County Courthouse toward Main Street, *c.* 1909. REO stands for Ransom E. Olds, who started the manufacturing of Oldsmobile vehicles. (Courtesy of Dick Chrisman.)

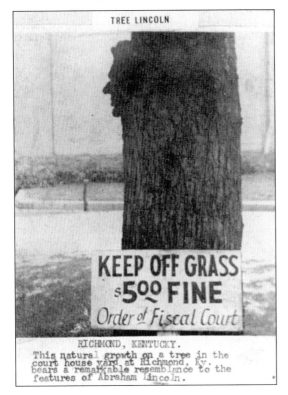

TREE LINCOLN

KEEP OFF GRASS
$5.00 FINE
Order of Fiscal Court

RICHMOND, KENTUCKY.
This natural growth on a tree in the court house yard at Richmond, Ky. bears a remarkable resemblance to the features of Abraham Lincoln.

LINCOLN TREE. Depicted in this image is a natural phenomenon: a maple tree on the west courthouse lawn with the silhouette of Abraham Lincoln. Age and deterioration brought about the tree's ending.

FRANCIS PIONEER MONUMENT. This monument was paid for by David R. Francis, the former governor of Missouri, upon his return to his native Richmond in 1906. This fountain was erected in 1906. Its original location was on the street level and was used as a watering trough during horse and buggy days. It has since been raised up into the courthouse lawn.

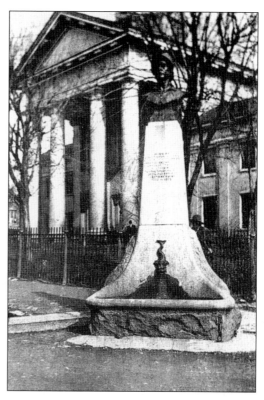

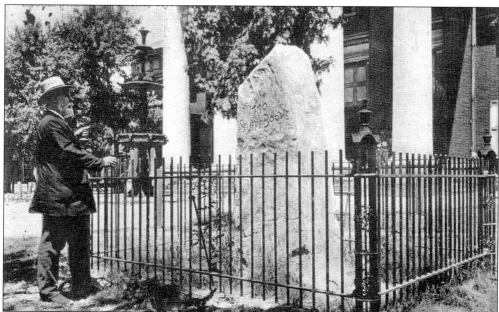

SQUIRE BOONE ROCK. This rock slab with the inscription "1770 Squire Boone" was found in southern Madison County between Pilot Knob and Big Hill and presented to the county by J. Len Ballard on October 7, 1892. It was on display in the courthouse lawn until 1965 when it was brought inside the courthouse and enclosed in glass to prevent deterioration.

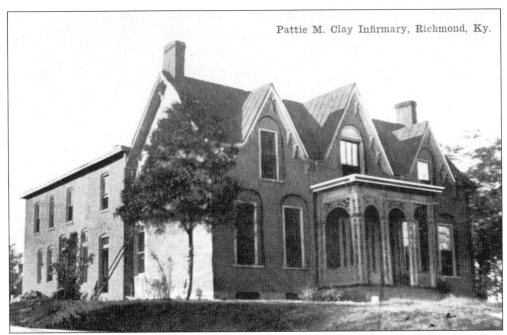

Pattie M. Clay Infirmary, Richmond, Ky.

PATTIE A. CLAY HOSPITAL. Built in 1892 and named for Pattie Amelia Clay, the hospital was originally located on Glyndon Avenue at Fourth Street. The new facility (below) was built in 1970 on the Eastern Bypass and is now known as the Pattie A. Clay Regional Hospital. It had a centennial observance on September 12, 1992. The former site is now occupied by the First Assembly of God. Another privately-owned hospital in Richmond was the Pope Hospital, built by Drs. Mason and Russell Pope and named for their father. The Madison County Detention Center now occupies this site.

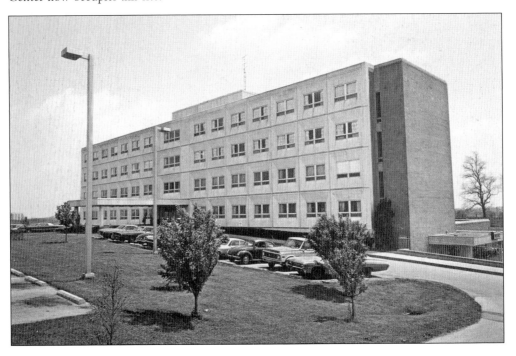

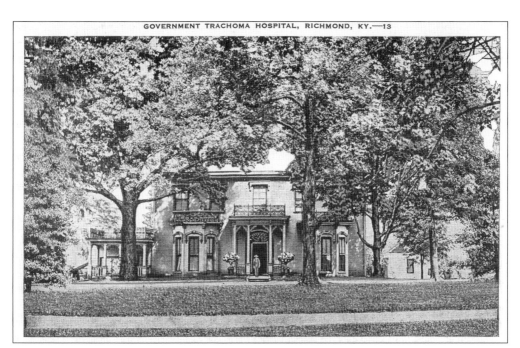

TRACHOMA HOSPITAL (LATER THE IRVINTON MUSEUM). This hospital was built for Dr. A.W. Rollins in the 1820s and sold to David Irvine, who later gave the property to his daughter Elizabeth after her marriage to William Irvine. Upon her death in 1918 the house and furnishings were bequeathed to the Medical Society of Kentucky. The house was used as a trachoma hospital until 1950 and is now the Irvinton Museum and Richmond Tourism Center.

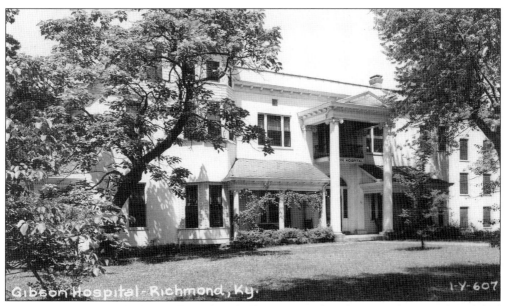

GIBSON HOSPITAL. This hospital was founded by Drs. Hugh and Moss Gibson on the Ezekiel Field property at the corner of Main and Fifth Streets. It was later inherited by a nephew, Dr. Shelby Carr. Dr. W.C. Cloyd was an associate with Dr. Carr. The site is now the location of a Chevron service station.

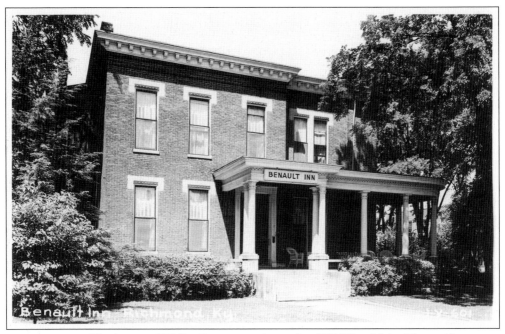

BENAULT INN. The home of Waller Bennet was located at 507 West Main. The residence was eventually turned into the Benault Inn. It was then replaced by a federal building in the 1970s and later became the site for the Madison County Public Library.

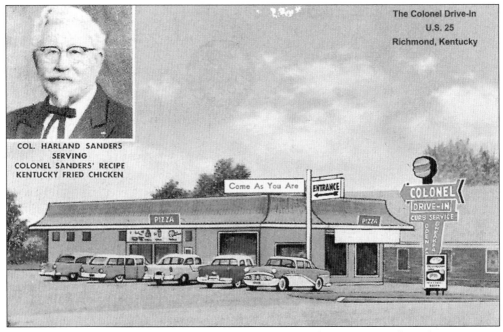

COLONEL DRIVE-IN RESTAURANT. This restaurant, shown here in images from the 1950s, was operated as a Kentucky Fried Chicken franchise by Lewis Broadus and Tony Sideris. It is now the location of a family restaurant.

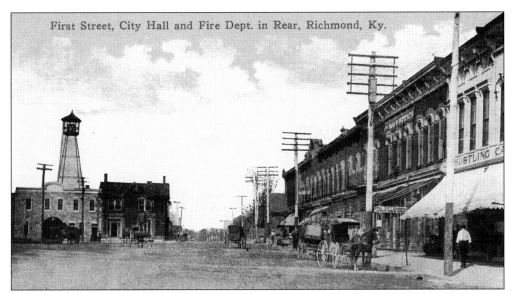

First Street, City Hall and Fire Dept. in Rear, Richmond, Ky.

FIRST STREET FIRE STATION. Located on Irvine Street, this was the only city fire station in 1912. The bell tower was used to summon the volunteer firemen. Next to it is the Miller Building, which contained the city hall, police station, and jail. It is now the site of the Madison Detention Center. On the upper story on First Street on the right is the *Climax* Office, which S.M. Saufley bought in 1917 in order to found the *Richmond Daily Register*.

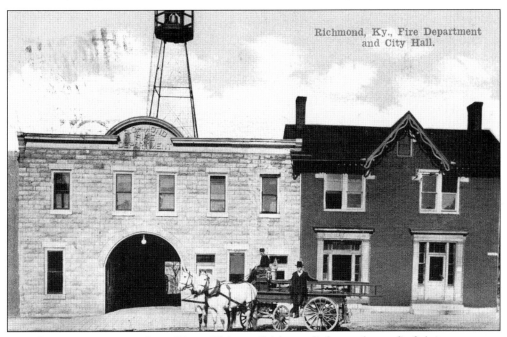

Richmond, Ky., Fire Department and City Hall.

FIRE DEPARTMENT AND CITY HALL. This was Richmond's horse-drawn firefighting apparatus in 1915 in front of the fire station on Irvine Street; it has been replaced by the Madison County Detention Center. The building at the right is the Miller Building, which housed Richmond's City Hall, which is now located in a former bank building on Main Street. Miller Building is now used as offices for a Court Designated Worker.

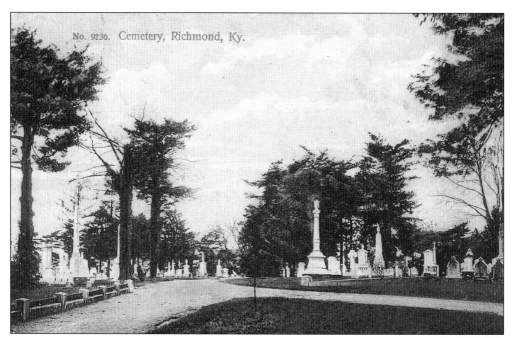

No. 9236. Cemetery, Richmond, Ky.

RICHMOND CEMETERY. Dedicated on May 30, 1856, Richmond Cemetery is the burial site of two governors (James McCreary and Keen Johnson), a Revolutionary War soldier, a Civil War Confederate soldier, five college presidents, and countless others who served in the military in World Wars I and II and in other military conflicts.

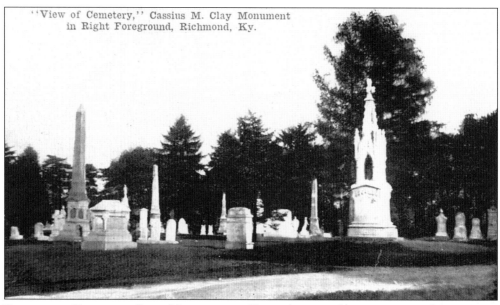

"View of Cemetery," Cassius M. Clay Monument in Right Foreground, Richmond, Ky.

RICHMOND CEMETERY CLAY MONUMENTS. Shown here are the monuments of Gen. Green Clay, Cassius Marcellus Clay I, Brutus J. II, and Lalla R. Clay. C.M. Clay was a noted abolitionist and aided in the establishment of Berea College. He served as the American ambassador to Russia during Abraham Lincoln's presidency and claimed credit for the purchase of Alaska in 1867.

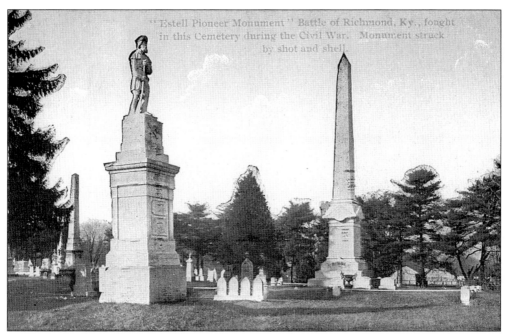

RICHMOND CEMETERY ESTILL MONUMENT. Capt. James Estill was killed in March 1782 by a Wyandot Indian. During the Battle of Richmond in 1862, the monument was struck by shot and shell.

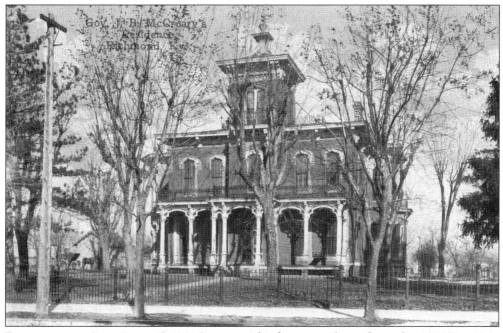

RESIDENCE OF GOV. JAMES B. MCCREARY. This former residence, located at 527 West Main Street, is now the Medical Arts Center. The tower was taken down and the top floor was eliminated in the process.

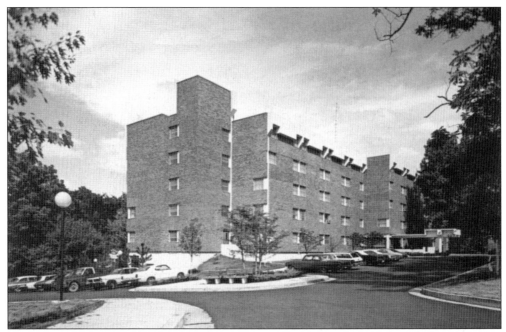

WILLIS MANOR. This all-electric high rise of 100 units for the elderly was named for local businessman B.E. Willis. This facility is owned and operated by the Housing Authority of Richmond.

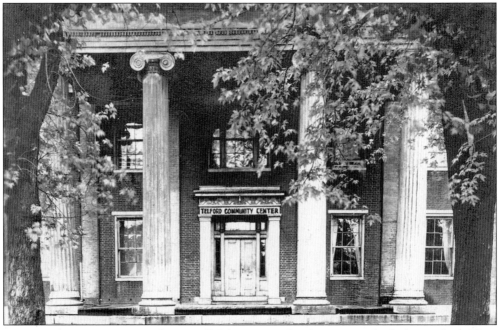

HOLLOWAY HOUSE. Located on Hillsdale Street, this house was built by Col. William Holloway, a leading Richmond merchant. At one time it was called the Telford Community Center in honor of the Reverend R.L. Telford. Bereans lodged there while fleeing from Kentucky in 1859. The house is now privately owned.

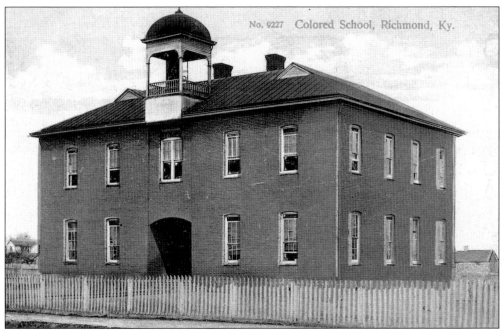

RICHMOND HIGH SCHOOL. During segregation this facility was a school for African-American students. Located on East Main Street, the building had a gym added. When segregation ended in 1955, its new name became Richmond Elementary School. The Telford YMCA complex is now located there.

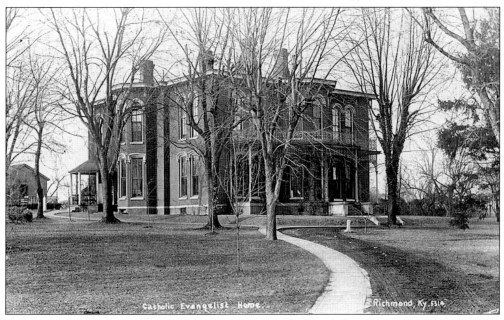

CATHOLIC EVANGELIST HOME. This ornate house at 416 North Second Street was built in 1872 by Squire Turner as a wedding gift for his daughter, Mary Turner Hood. After being purchased in 1905 by the Covington Diocese of Catholics, it was used for five years as the center of missions in the mountains.

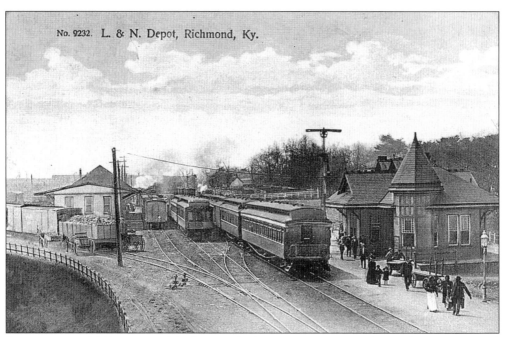

No. 9232. L. & N. Depot, Richmond, Ky.

RICHMOND L&N DEPOT. In this photograph, the camera was pointed toward Main Street and the view catches several vintage passenger cars in the Richmond station. Several freight box cars can be seen on the left.

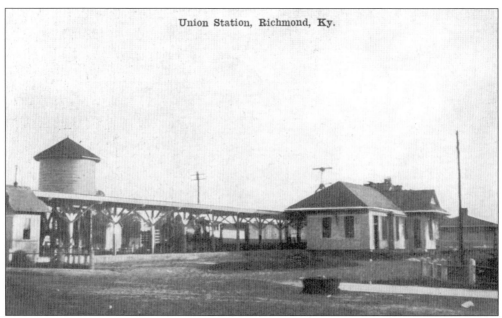

Union Station, Richmond, Ky.

RICHMOND UNION STATION. This card, postmarked in 1911, shows a locomotive with freight cars that has stopped in Richmond. Since water was essential for steam, that is a water tower rising above the covered walkway built for passengers on the *Southland* and *Flamingo* before service was ended in 1968. Since there were no electronic arms to control traffic at street crossing, the shack on the left was for watchmen.

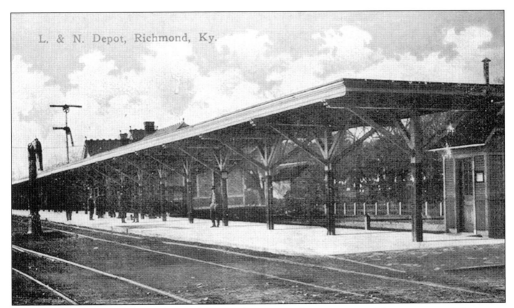

RICHMOND L&N DEPOT. This card shows the canopy for passengers. The canopy and the water tower were removed soon after passenger service was ended in 1968. The equipment to the left was used to fill the locomotives with water to make steam. On the right is the shack for the watchman who used a stop sign to control traffic at the Main Street crossing. Safety signals can be seen just to the right of the water spout.

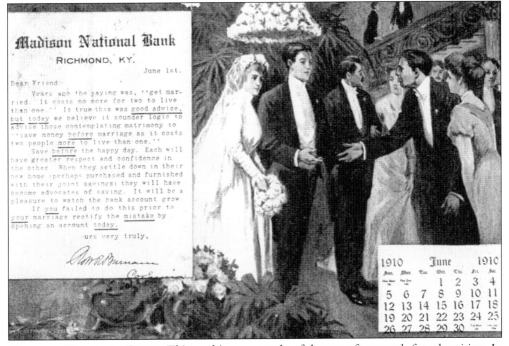

MADISON NATIONAL BANK. This card is an example of the use of postcards for advertising. In 1910 the Madison National Bank issued a series of calendar cards with appropriate themes. This one shows weddings for the month of June.

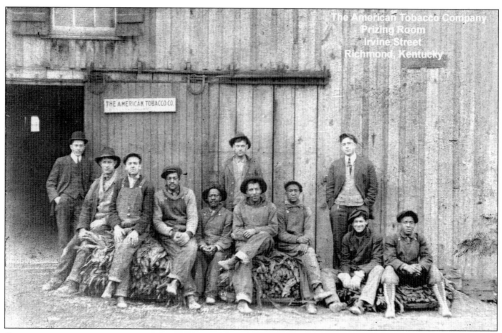

AMERICAN TOBACCO COMPANY. Depicted in this image are workers at the prizing room for tobacco after it was brought to the warehouse sale. Tobacco was processed here and then put into hogsheads on Irvine Street in Richmond. The building was located near the L&N Railroad for shipment. This photo was taken in the 1930s. (Courtesy of George and Vickie Miller.)

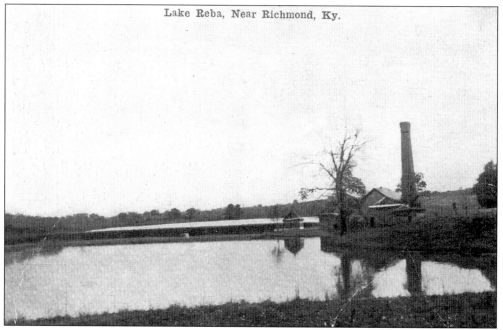

LAKE REBA. Located on Irvine Road, the pump house provided the water supply to the City of Richmond from Lake Reba. Twin pipes now carry water from the Kentucky River at College Hill. The Lake Reba and Gibson Bay Recreational Sports Complex now utilizes this site.

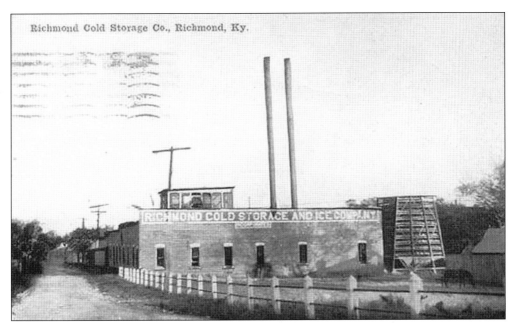

RICHMOND ICE COMPANY AND COLD STORAGE. This business was organized in 1905. A man-made lake was formed to supply water for the manufacturing of ice. A railroad spur was built so that cars from both the Louisville & Nashville and the Louisville & Atlanta could be loaded directly from the building. The structure has since been demolished, and the lake has been filled in.

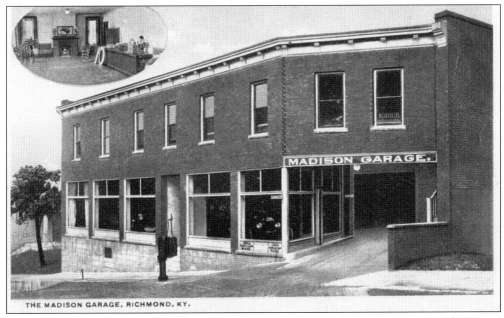

MADISON GARAGE. Rice Woods and Henry White operated this business on South Second Street. Rice's son, Ernest Woods, operated the Chevrolet dealership, which became Salyer Chevrolet in 1954. Ray Salyer and Jack Burford moved the firm to the Eastern Bypass location in 1965.

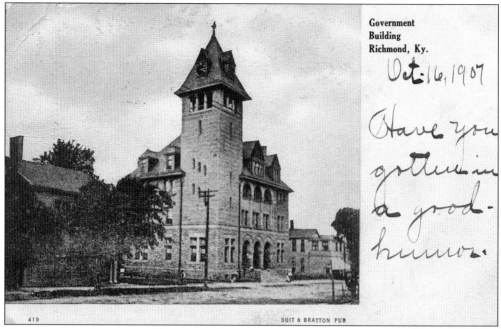

Government
Building
Richmond, Ky.

Oct: 16, 1907

Have you gotten in a good humor.

GOVERNMENT BUILDING. This scene shows the government building and post office as it looked in 1907. The residence on the left was replaced by an auto dealership for Dodge and Plymouth cars. The buildings on the right were destroyed by a fire in 1953.

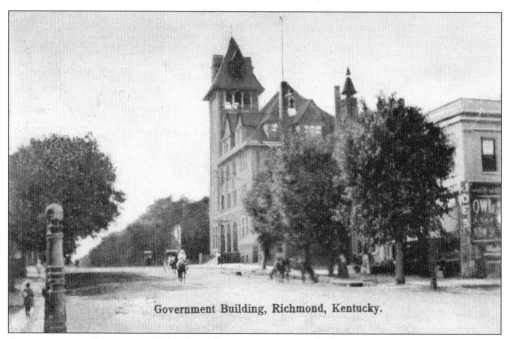

Government Building, Richmond, Kentucky.

GOVERNMENT BUILDING. This view shows Main Street before it was paved and when the popular mode of travel was horse and buggy. The shop on the corner (Joe's) was once used as bank, and its firewalls spared it from the 1953 fire that destroyed all the structures up to the government building.

GOVERNMENT BUILDING AND POST OFFICE. Constructed in 1891, this building served as a post office until 1961 and as a federal courthouse. It once served as Richmond City Hall and has now reverted back to its former use as Richmond Hall of Justice. This view was taken after a garage was built on the corner. The facility was later used as the main station for the fire department.

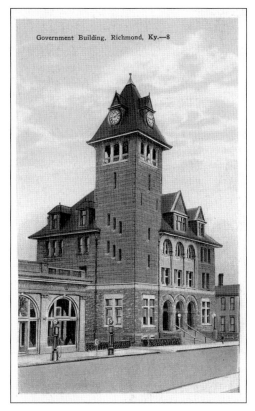

Government Building, Richmond, Ky.—8

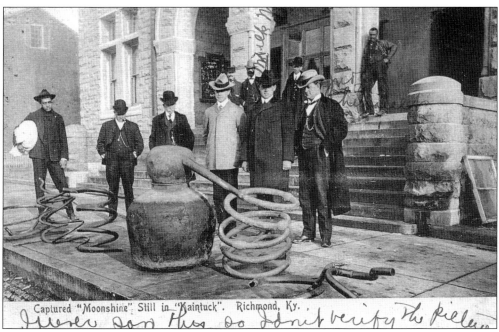

Captured "Moonshine" Still in "Kaintuck". Richmond, Ky.

GOVERNMENT BUILDING. Various and sundry items of evidence were often brought before the federal court. This picture shows a captured moonshine still confiscated by the "revenooers [*sic*]."

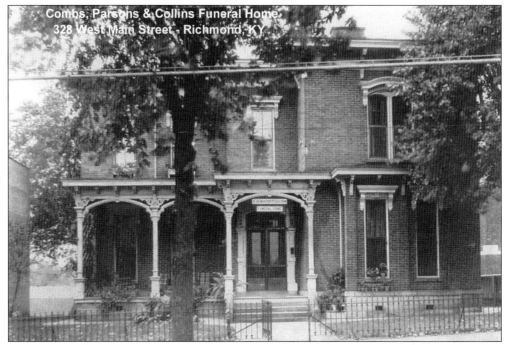

COMBS, PARSONS & COLLINS FUNERAL HOME. This Main Street business started in 1979; it is operated by Shannon Combs, Paul Parsons, and Johny Collins. The building has been used as a funeral home since 1906. Before that it was the home and office of Dr. David J. Williams.

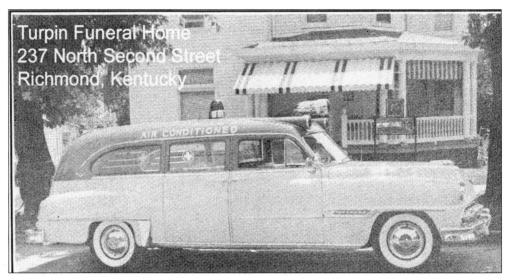

TURPIN FUNERAL HOME. Founded in 1929, this family-owned business was located at the corner of North Second and Irvine Streets before moving in 1946 to its present home at 237 North Second Street. Shown here is the first air-conditioned ambulance in Madison County. Coleman and Joyce Turpin and their daughter Paula Turpin Bowman are owners.

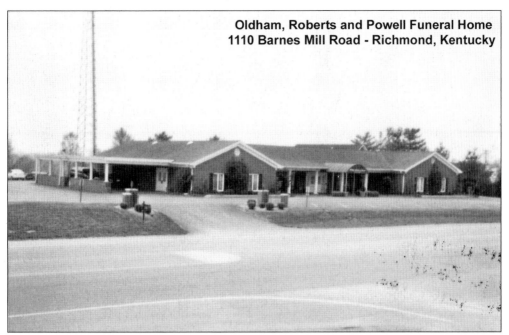

OLDHAM, ROBERTS AND POWELL FUNERAL HOME. In 1906, Burton Roberts became the first funeral director in Richmond. He opened the city's first funeral home with Joe Oldham and Rufus Blakeman. In 1935, Blakeman sold his interest to Luther Powell, and the funeral home became Oldham, Roberts & Powell Funeral Home. It was located on Main Street for 72 years, before moving in 1978 to a new modern facility with a larger chapel and parking lot on the Barnes Mill Road.

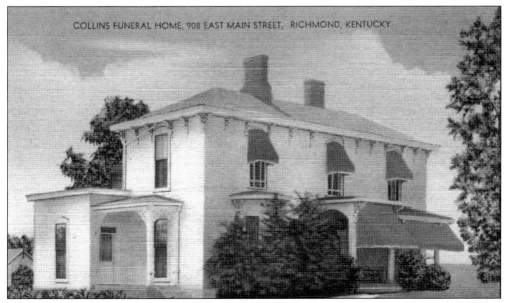

COLLINS FUNERAL HOME. Squire and Albirda Collins operated this funeral home at 908 East Main Street to care for the needs of the African-American community. After they both passed, this stately mansion was torn down and is now the site of a shopping center.

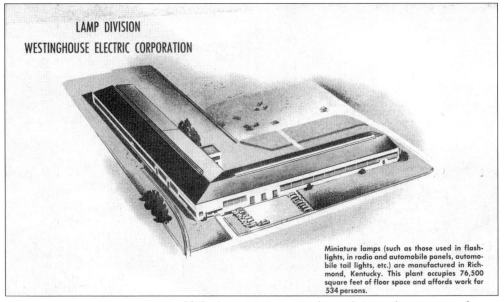

LAMP DIVISION
WESTINGHOUSE ELECTRIC CORPORATION

Miniature lamps (such as those used in flashlights, in radio and automobile panels, automobile tail lights, etc.) are manufactured in Richmond, Kentucky. This plant occupies 76,500 square feet of floor space and affords work for 534 persons.

WESTINGHOUSE ELECTRIC. Established in 1948 in Richmond in order to manufacture miniature light bulbs, Westinghouse Electric was one of the earliest manufacturers. It offered employment to many people, mostly women, until it was sold to Phillips Lighting in 1983. Phillips closed its operations 10 years later, and the building is now owned by the Madison County Board of Education.

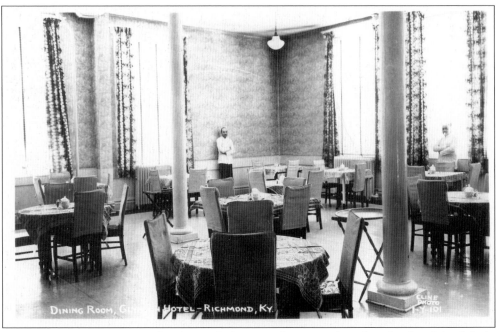

GLYNDON DINING ROOM. This dining facility served as a meeting place for the civic clubs in the 1940s and 1950s. Sunday dinners were a specialty at the dining room.

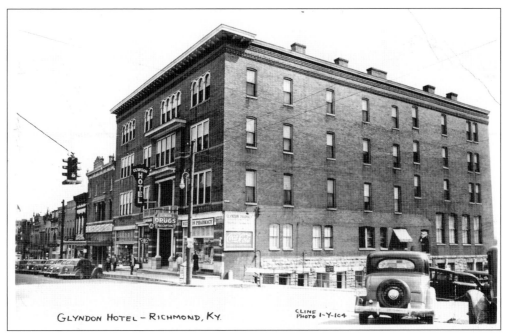

GLYNDON HOTEL – RICHMOND, KY.

CLINE PHOTO 1-Y-104

GLYNDON HOTEL. This hotel has been a welcome haven for weary travelers since 1889. After the first building was destroyed by fire, the present one opened in the fall of 1889. Many different businesses have been located in the corner next to the lobby, including Glyndon Pharmacy, Cornett Drug, and Burd Drug. The present tenant is Woody's Restaurant.

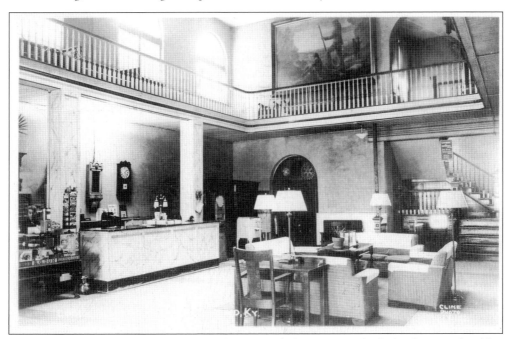

GLYNDON HOTEL LOBBY. This image shows a real photo postcard of Glyndon Hotel Lobby. Much of this nostalgic atmosphere is still present today. Many notable figures on both the state and national level have been guests here.

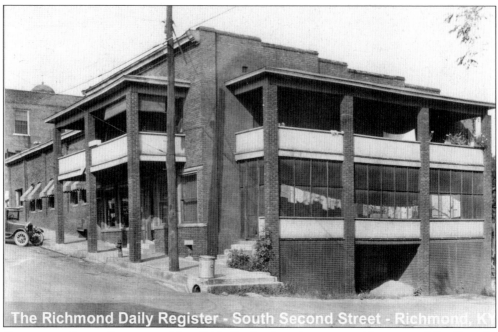

The Richmond Daily Register - South Second Street - Richmond, KY

RICHMOND DAILY REGISTER. After S.M. Saufley bought two weekly papers (*The Kentucky Register* and *The Climax*) and combined them in 1917 to form *The Richmond Daily Register*, this plant was built on South Second Street. It was home to *The Richmond Daily Register* until 1978 when the paper relocated to Big Hill Avenue. The vehicle shown here is a 1927 Pontiac truck.

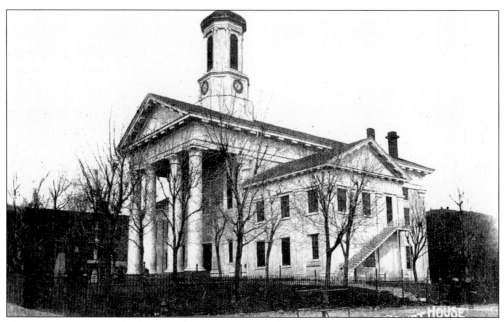

MADISON COUNTY COURTHOUSE. This view, postmarked 1916, shows an iron fence that surrounded the courthouse and was used to impound about 1,200 Union prisoners after the Battle of Richmond in 1862. The fence is now used as the Main Street border of Richmond Cemetery. The iron fountain and bandstand were razed for scrap metal during World War II.

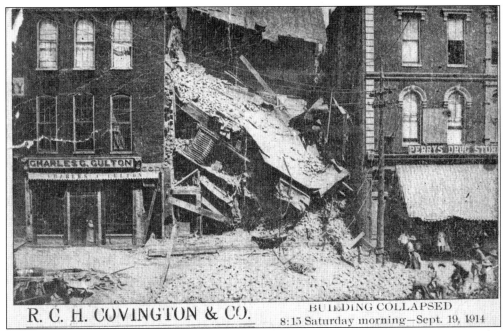

R. C. H. COVINGTON & CO.

BUILDING COLLAPSED
8:15 Saturday morning—Sept. 19, 1914

R.C.H. COVINGTON & COMPANY. This West Main Street structure collapsed at 8:15 a.m. on Saturday September 19, 1914. Another building on this site, Green's Richmond Supply Store, buckled after being weakened by a fire that destroyed many businesses on this block in 1973.

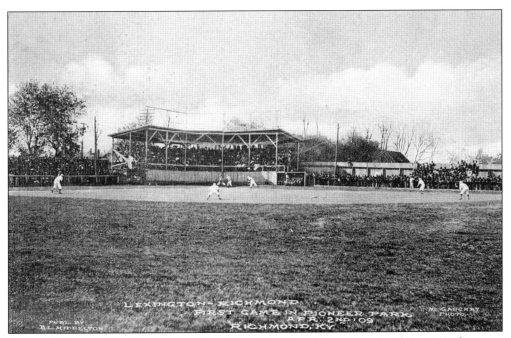

PIONEER PARK. The first game to be played in this park was on April 2, 1909, between Lexington and Richmond. Two early businesses are represented on the photo: B.L. Middleton, a publisher, and McGaughey Studio, both longtime places to go for all types of photographs.

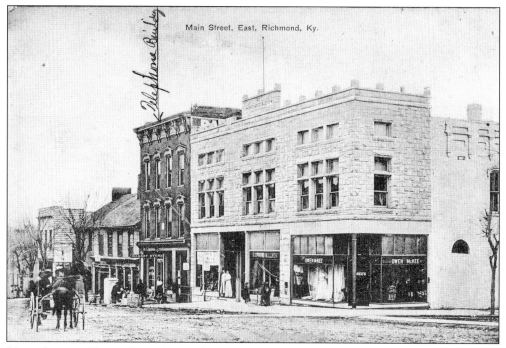

MAIN STREET, EAST. Owen McKee's Department Store dominated this corner at First Street. Notice the dresses of the ladies in the doorway and in the display window. Horse and buggy was the mode of travel at the time. The adjacent building housed the telephone company.

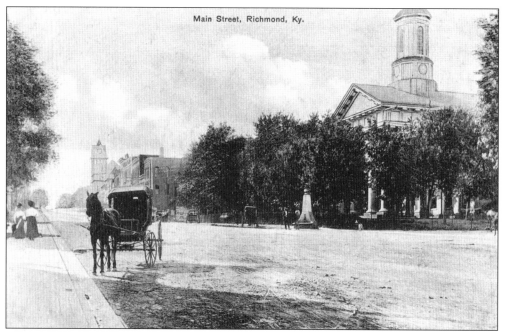

MAIN STREET. This image is another view of Main Street in the "horse and buggy" days. Taken in front of the courthouse, it is quite evident that the Francis Fountain is down on street level to satisfy the real reason for its existence, a watering trough for animals.

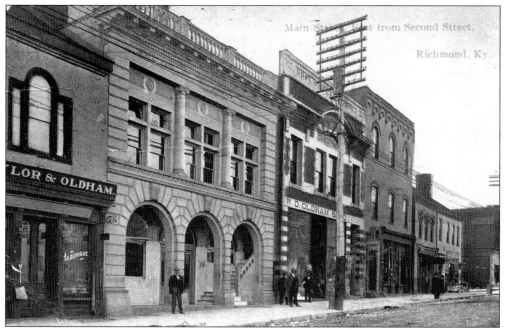

MAIN STREET, EAST. Shown in this card are the Taylor & Oldham Hardware, the State Bank & Trust Company, the W.D. Oldham Building, the Madison National Bank, and Ricci's Restaurant. All of these companies have since been replaced. Ricci's was replaced by the Elks Lodge, and BankOne and Community Trust Bank now occupy the entire block up to Richmond Drug.

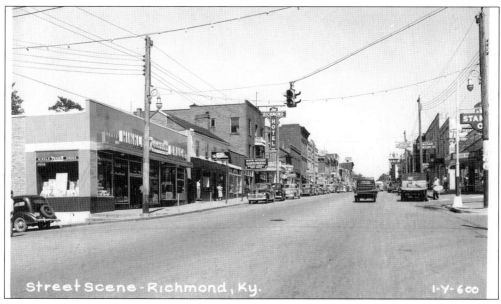

MAIN STREET. In a view looking west from Madison Avenue, the Hinkle Drug Store, the Jewel Box, White Kitchen, and the New Richmond Hotel are easily identified on the south side. On the north side are Lex Phelps Standard Oil, Kroger Supermarket, Bingham Furniture, and Witt Motor Company (Ford). The automobiles date to the late 1930s and early 1940s.

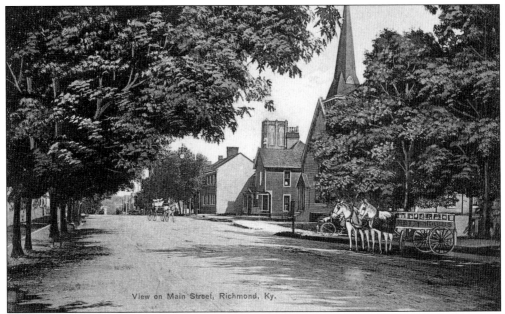

VIEW ON MAIN STREET. This card, postmarked 1909, depicts the block from Lancaster Avenue looking east. Shown here are the spire of the First Baptist Church, the frame residence that W.B. Tate owned in 1953, and the Jere E. Sullivan Building. Both were once part of the parking lot of First Baptist on Main Street. The tower of First Presbyterian Church can also be seen.

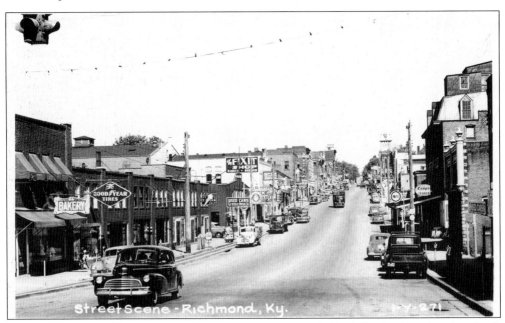

MAIN STREET. Looking west from Collins Street, the whole block has been replaced on both sides. The Richmond Bakery, Goodyear, and Kentucky Ice Cream on the left and the Richmond Water and Gas, the Pure Oil Station, and Zaring's Mill on the right are just memories. Also shown are the IOOF Building (Fixit Shop, Madison Theatre), Madison Motors, and Ken Car, which was destroyed by fire in 1967. The cars are from the late 1930s and early 1940s.

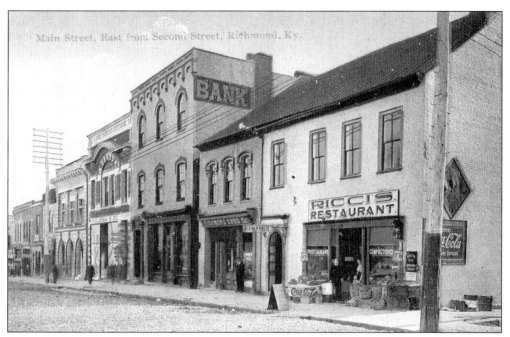

RICCI'S RESTAURANT. On Main Street at South Second Street, the BPOE replaced Ricci's with lodge rooms and a retail rental space. The Richmond Drug building is the only one on the whole block between First and Second Streets still standing.

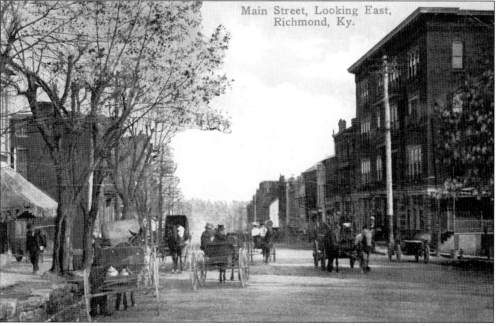

MAIN STREET. Shown here is a view of Main Street looking east. On the right is the Glyndon Hotel with steps leading up to the side wooden porch (which has since been removed) as well as the block between Second and Third Streets. Notice that there is only one automobile in the midst of all the horse-drawn vehicles.

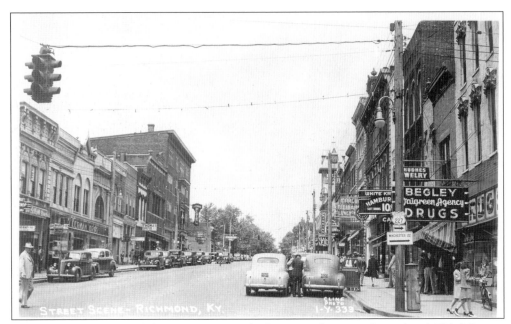

MAIN STREET. This card shows Main Street looking west between Second and Third Streets. Businesses on the left side included Paul Jett Shoes, Lerman Bros., Thomas Furniture, and the Glyndon Hotel. On the right side are Begley Drug, Hughes Jewelry, White Kitchen, Marcum's Billiards, the Masonic Temple, the Ideal Cafe, and W.F. Higgins Furniture.

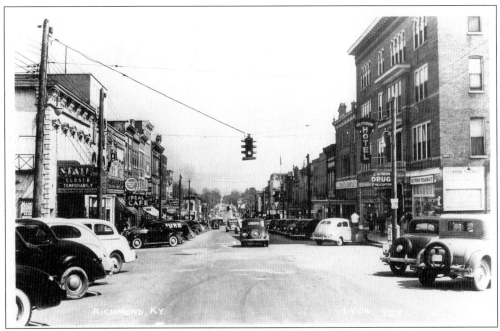

MAIN STREET. Depicted here are the businesses between Second and Third Streets looking east. On the left, businesses include the State Theatre (later called Towne Cinema after a fire at Madison Theatre), the Ideal Cafe, and Western Auto Store. On the right is shown Glyndon Hotel, Glyndon Pharmacy, Elder's Federated, and J.C. Penney.

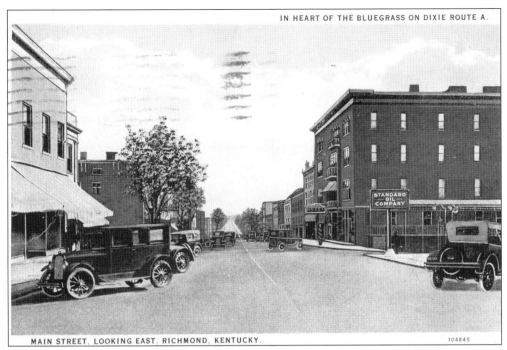

MAIN STREET, LOOKING EAST, RICHMOND, KENTUCKY.

104845

MAIN STREET. This view looking east shows the intersection of Main Street and Third Street. Some of the vintage automobiles in this image are the 1925 Essex and the 1921 Plymouth. On the right is Schilling's Standard Service Station, and on the left is Joe's Delicatessen.

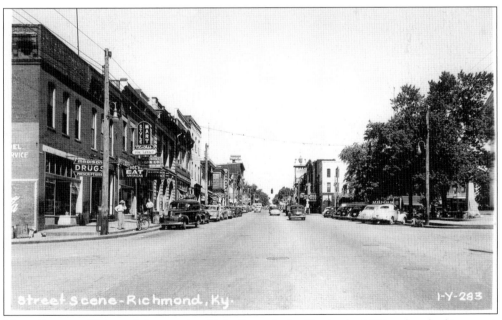

Street Scene-Richmond, Ky.

1-Y-283

MAIN STREET. This card shows what Main Street looks like in the 1950s when looking west. New businesses had appeared, including Madison Drugs, Doc's Restaurant, Jim Leeds Clothing, Richmond Loan, and J.J. Newberry. Main Street had been paved, and the Francis Monument had been raised from street level.

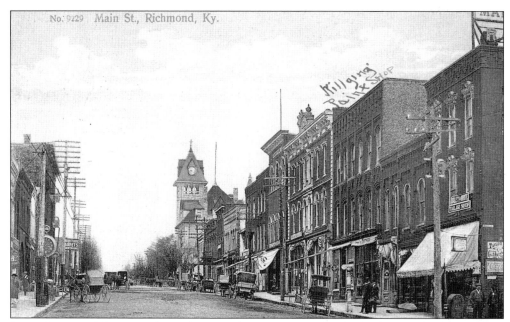

MAIN STREET. This view shows the scene between Second and Third Streets looking west in 1910. Willging Paint Store can be identified. Also, a sign on the left at the Welch Hardware advertises furniture, carpets, and undertaking. This sign was not a rarity because undertaking was often a sideline in many furniture stores.

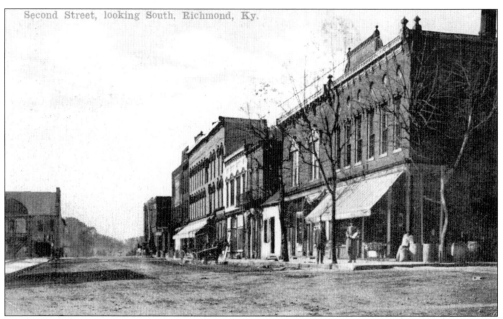

Second Street, looking South, Richmond, Ky.

SECOND STREET. This card, postmarked in 1911, depicts a scene looking south from Irvine Street. The building behind the horse and buggy was the St. Charles Hotel. It then became Douglas & Simmons Hardware, then Best-Lovell Hardware, and is now owned by the City of Richmond as office space. On the left is the bandstand on the courthouse lawn as well as Ricci's Restaurant.

Three
EASTERN KENTUCKY
UNIVERSITY

The campus in Richmond has borne six names. When the courts awarded Centre College in Danville, Kentucky, to the northern faction of the Presbyterian Church, the Southerners sought a location of their own. Richmond was chosen and Central University was founded in 1873. However, due to financial difficulties and reconciliation at Danville, the campus at Richmond was moved there in 1901 and merged with Centre College. Walters Collegiate Institute, a boys' college preparatory school, was the next institution to occupy the campus. It remained there until 1906 when the campus was selected as the site for one of two normal schools approved by the state legislature. Eastern Kentucky State Normal School, dedicated primarily to teacher training, was opened in 1906. In 1924 the school became known as Eastern Kentucky Teachers College. That name was changed in 1948 when the status was changed to Eastern Kentucky State College. By 1966 Eastern attained university status and became Eastern Kentucky University.

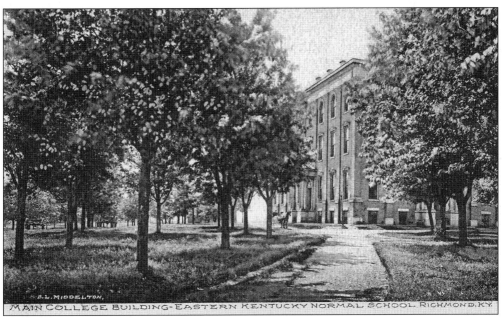

UNIVERSITY BUILDING. This structure was built in 1874 as the main building for Central University, which opened on September 22, 1874.

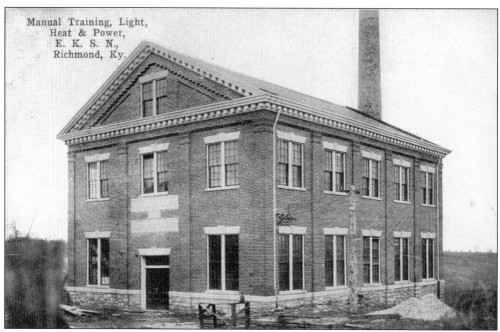

POWER PLANT. This facility housed the manual training, light, heat, and power operations during the time of Eastern Kentucky State Normal School. The power plant was adequate for the small number of buildings that it had to service.

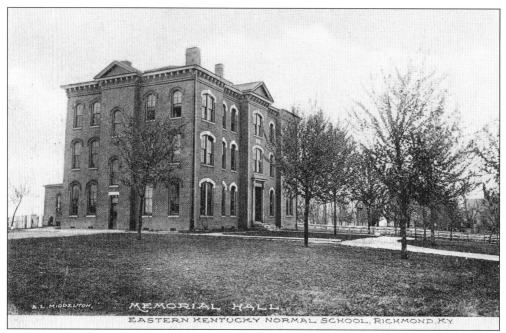

MEMORIAL HALL. Memorial Hall was one of the five buildings on the Central University campus. The main structure was torn down in 1936 and an addition was removed in 1961 to make room for the Earle B. Combs Dormitory.

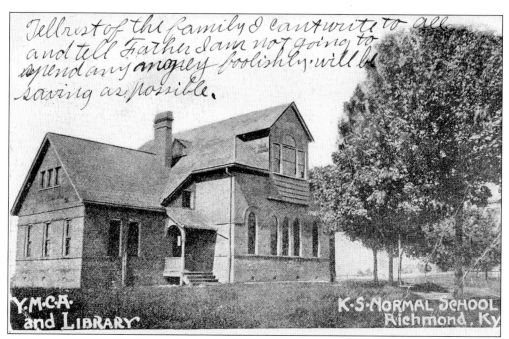

Tell rest of the family I can't write to all and tell Father I am not going to spend any money foolishly. will be saving as possible.

Y.M.C.A. and LIBRARY.

K·S·NORMAL SCHOOL Richmond, Ky.

YMCA AND LIBRARY. This building served a dual purpose as both the YMCA and the library for Eastern Kentucky State Normal School. This card was postmarked in 1913.

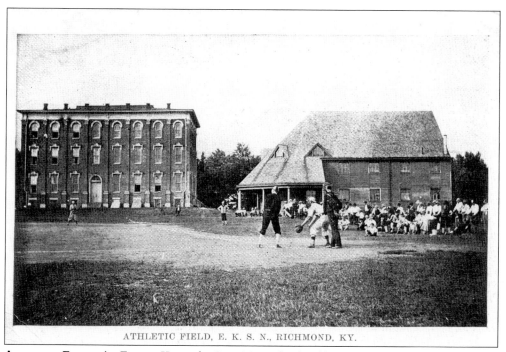

ATHLETIC FIELD, E. K. S. N., RICHMOND, KY.

ATHLETIC FIELD. An Eastern Kentucky State Normal School baseball game is in progress on the athletic field. The building on the right is the Miller Gymnasium, which burned down in 1921. University Hall is the building in the background on the left.

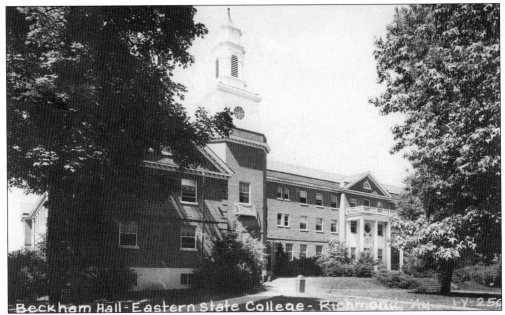

BECKHAM, MCCREARY, AND MILLER HALLS. This unit of dormitories was constructed in 1938 by the Works Progress Administration (WPA). Each hall was named in honor of a political leader who had promoted the establishment of the Eastern Kentucky State Normal School in Richmond.

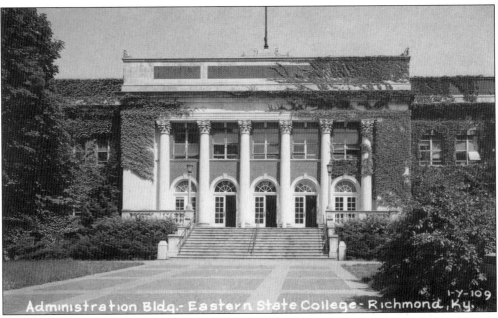

ADMINISTRATION BUILDING. Constructed in 1928, this building was named for Thomas Jackson Coates, Eastern's third president. In 1929 the Hiram Brock Auditorium, which had 1,850 seats, was added to the rear of the building. The auditorium underwent renovation in 1964. Administrative offices and the campus mail room and printing service are located inside.

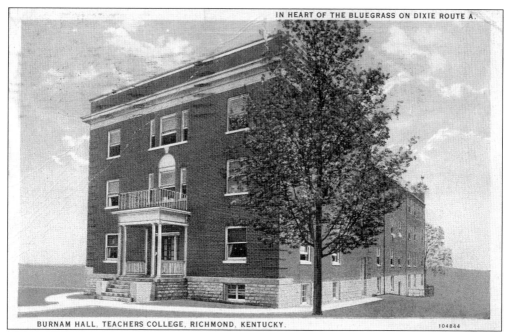

BURNAM HALL, TEACHERS COLLEGE, RICHMOND, KENTUCKY.

104844

BURNAM HALL. Built in 1921, this women's dormitory was named to honor Anthony Rollins Burnam, a state senator, court of appeals justice, and prominent resident of Richmond. He influenced the decision to locate one of the normal schools in Richmond. The top card shows the dormitory before an addition in 1926.

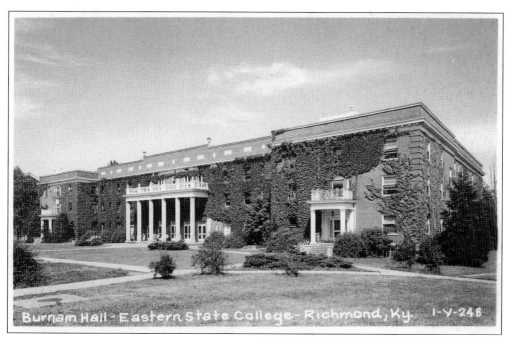

Burnam Hall - Eastern State College - Richmond, Ky. I-Y-248

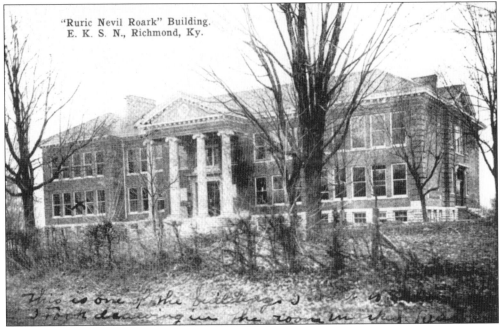

"Ruric Nevil Roark" Building.
E. K. S. N., Richmond, Ky.

This is one of the buildings I took dancing in the room in the ...

ROARK BUILDING. This building was erected in 1908 and named for Ruric Neville Roark, Eastern's first president. It is now used as for the sciences.

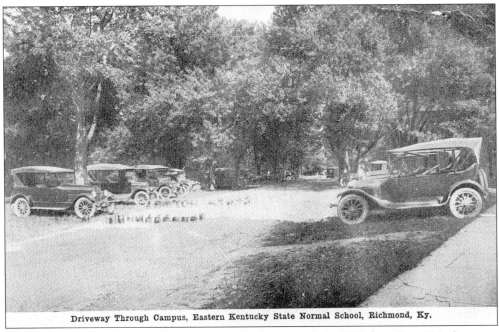

Driveway Through Campus, Eastern Kentucky State Normal School, Richmond, Ky.

CAMPUS DRIVEWAY. This card was sent as a thank you reply in 1920 from Pres. T.J. Coates to the president of the State Normal School in Valley City, North Dakota. Notice that the card depicts Model T Fords.

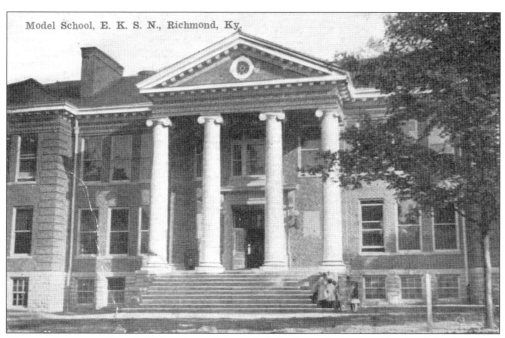

Model School, E. K. S. N., Richmond, Ky.

MODEL SCHOOL. Roark Hall, pictured here, briefly housed the model school in the teens. Model students are now quartered in the Donovan Building, which was named in honor of H.L. Donovan, an Eastern president from 1928 to 1941.

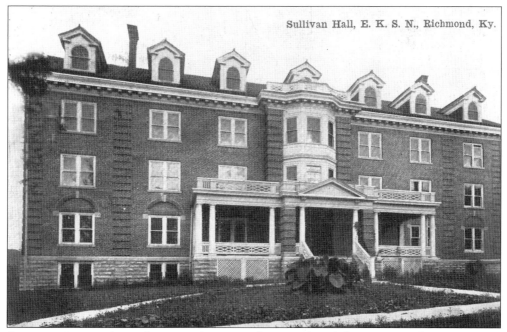

Sullivan Hall, E. K. S. N., Richmond, Ky.

SULLIVAN HALL. Shown here is a dormitory that was named for Jere A. Sullivan, a Central University graduate and prominent attorney as well as the first Madison Countian to serve on Eastern's Board of Regents. The dormitory was built in 1908.

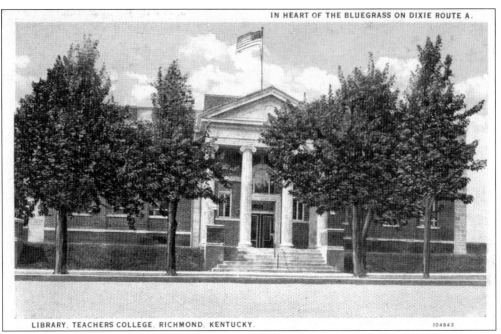

LIBRARY, TEACHERS COLLEGE, RICHMOND, KENTUCKY.

JOHN GRANT CRABBE LIBRARY. This library was named in honor of Eastern's second president. The original structure was erected in 1923 and was given an addition in 1936. In 1967 Crabbe Library underwent major expansion and renovation. At this time, the library was joined together with University Building. The Thomas and Hazel Little Building was added in 1994 to make one large complex with volumes of the past and technology of the future.

THOMAS AND HAZEL LITTLE BUILDING. When Crabbe Library was enlarged and joined with University Building, the new addition was named the Thomas and Hazel Little Building.

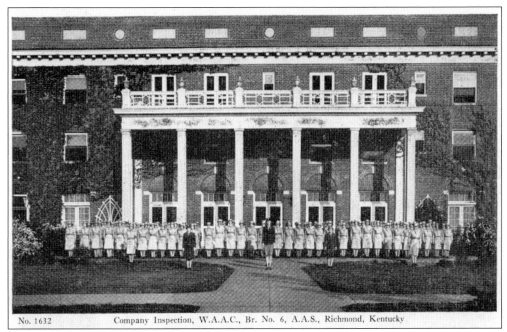

No. 1632 Company Inspection, W.A.A.C., Br. No. 6, A.A.S., Richmond, Kentucky

W.A.A.C. BRANCH NO. 6 A.A.S. COMPANY. This image shows an inspection formation in front of Burnam Hall, where they were quartered during the eight-week training period.

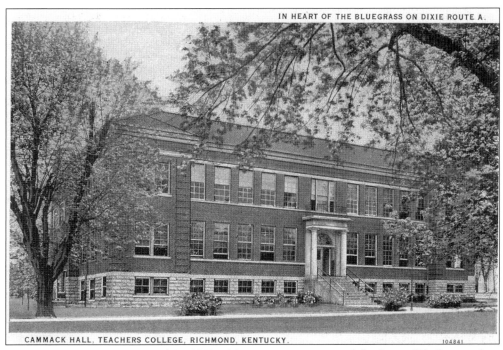

IN HEART OF THE BLUEGRASS ON DIXIE ROUTE A.

CAMMACK HALL, TEACHERS COLLEGE, RICHMOND, KENTUCKY. 104841

CAMMACK BUILDING. Erected in 1918, this structure was named for James W. Cammack, a member of Eastern's Board of Regents from 1906 to 1931. The Cammack Building was used for the elementary division of the training school. At one time it also housed the library, and it is now used for classrooms and departmental offices.

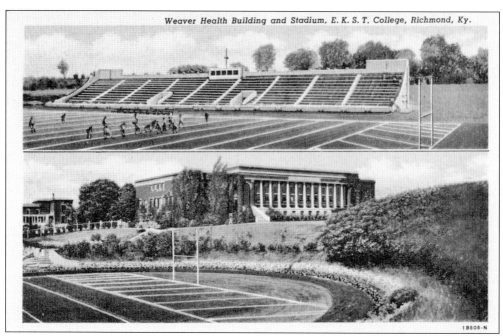

Weaver Health Building and Stadium, E. K. S. T. College, Richmond, Ky.

WEAVER HEALTH BUILDING AND HANGER STADIUM. The Weaver Health Building was constructed in 1931 and named for Charles W. Weaver, a regent from 1920 to 1932. Hanger Stadium was built in 1936 and named for Arnold Hanger, a builder, and demolished after the 1967 football season. It had a seating capacity of 5,000.

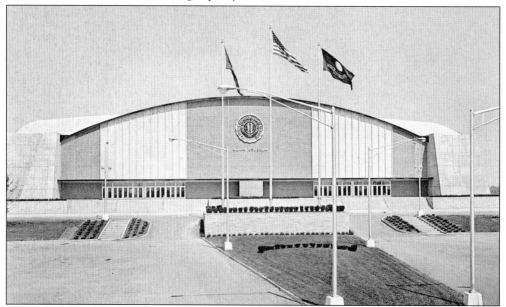

ALUMNI COLISEUM. Vice President Lyndon B. Johnson lifted the first spadeful of dirt for the groundbreaking on June 1, 1961. Eastern's basketball facility had its inaugural season during the 1963–1964 school year. The laminated cross-arches of the world's largest roof of its kind (in 1963) span 308 feet. The coliseum was named as a tribute to the many thousand past and future alumni of Eastern.

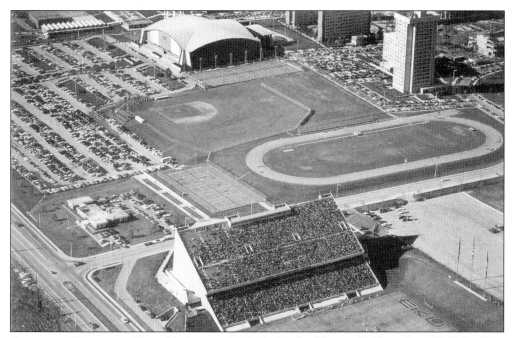

ATHLETIC COMPLEX. The athletic complex includes the Hanger Field on Roy Kidd Stadium (under the Robert R. Begley Building), the Tom Samuels Track, the Turkey Hughes Baseball Field, Alumni Coliseum, and the Donald Combs Natatorium.

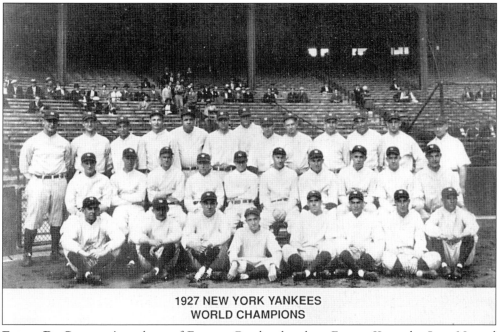

1927 NEW YORK YANKEES
WORLD CHAMPIONS

EARLE B. COMBS. A graduate of Eastern, Combs played on Eastern Kentucky State Normal School baseball team in 1919, with the Louisville Colonels, and finally with the New York Yankees alongside Babe Ruth and Lou Gehrig. He was the first native Kentuckian inducted into Baseball's Hall of Fame in 1970. Combs is shown on the second row, third from left.

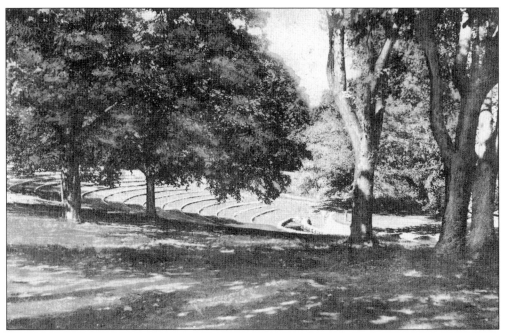

AMPHITHEATER. This structure is a replica of an ancient Greek amphitheater. It was built in 1936 and has a seating capacity of 2,500. After the addition of the Van Perseum Music Pavilion in 1962, many concerts as well as college commencements are staged there.

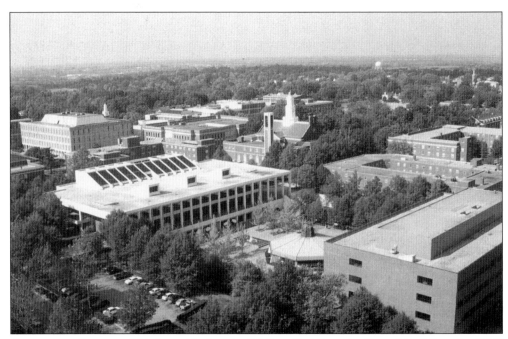

CENTER OF CAMPUS. This image depicts the Wallace Building, the Powell Building, the EKU Meditation Chapel, and the Keen Johnson Building.

STEPHEN COLLINS FOSTER MUSIC BUILDING. The music facility (above) was named for Stephen Collins Foster, the composer of "My Old Kentucky Home." The Stephen Collins Foster band camp was started in 1936. The band (below) had as its director James E. Van Perseum (shown in inset), who was the head of the music department. The music pavilion that was constructed in 1962 carries his name. Behind it is a slab marking the grave of Mozart, a large black dog who was buried there in 1964 after being adopted as the band's mascot for many years.

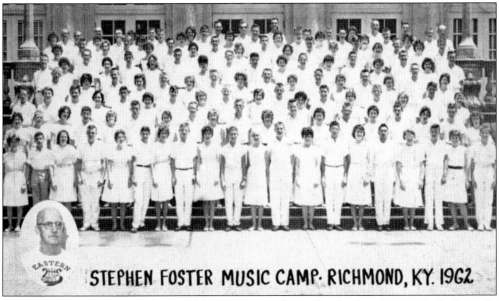

STEPHEN FOSTER MUSIC CAMP. This 1962 image shows the Stephen Foster Music Camp in Richmond, Kentucky.

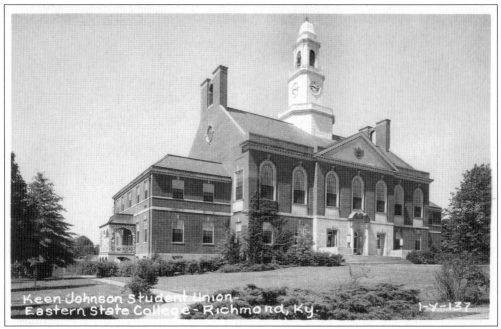

KEEN JOHNSON BUILDING. Another project built in 1939 by the WPA, the Keen Johnson Building bears the name of a man who served as both the governor of Kentucky (1939–1943) as well as the regent of Eastern (1936–1946; 1954–1956). Once the Student Union Building, it now houses the University Bookstore in the basement.

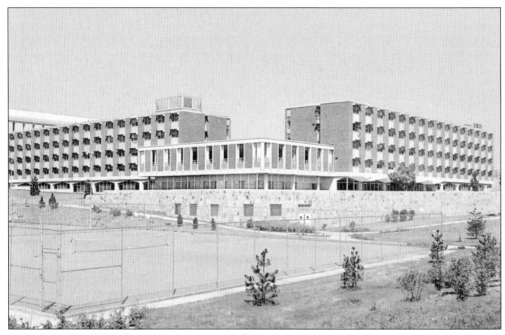

MARTIN HALL. This dormitory was named for Eastern president Robert R. Martin. It houses 400 male students and also has a cafeteria and recreation areas.

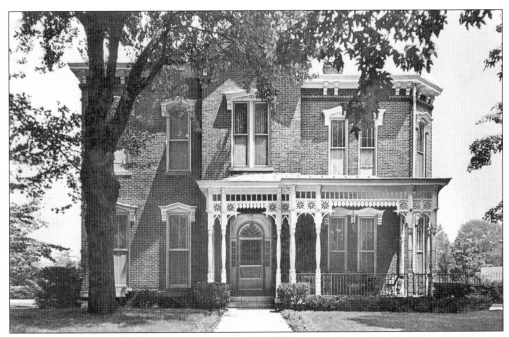

BLANTON HOUSE. This house was constructed in 1887 as a residence for the Central University chancellor. It has served as the home of Eastern's presidents since 1912.

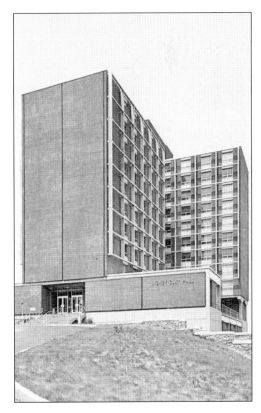

SIDNEY CLAY HALL. This picture shows the 11-story dormitory that is named for Sidney Clay, a member of the Board of Regents at Eastern.

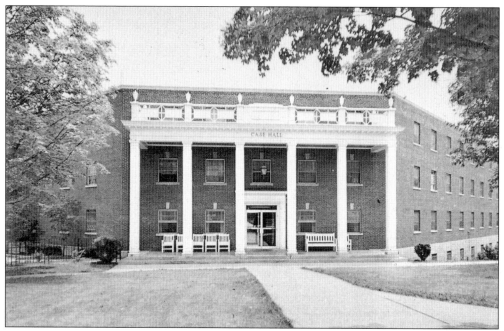

CASE HALL. This dormitory houses 550 women as well as offices for several departments. It was named for Emma Y. Case, who once served as Dean of Women at Eastern.

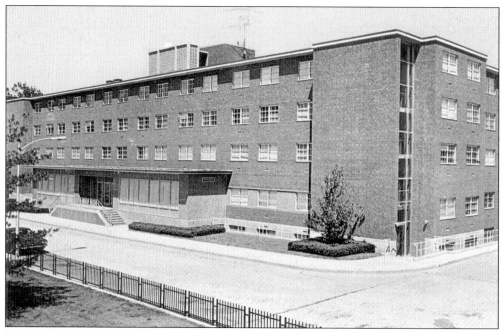

MCGREGOR HALL. This dormitory houses 448 women students. It was named for Judge Thomas B. McGregor, a former member of the Board of Regents at Eastern.

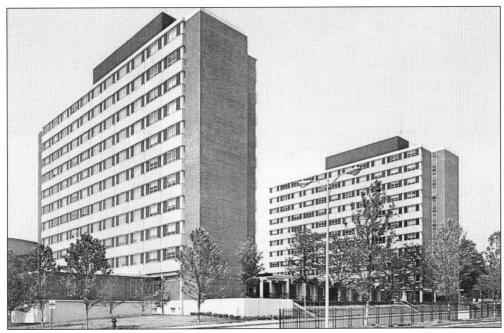

DUPREE AND TODD HALLS. These buildings are twin 12-story dormitories, each of which houses 360 men. They were named for Regents Russell I. Todd and F.L. Dupree.

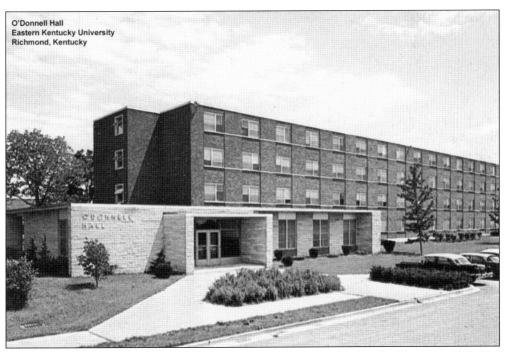

O'DONNELL HALL. This structure was named after W.F. O'Donnell, who succeeded H.L Donovan as the president of Eastern. O'Donnell was the superintendent of Richmond City Schools. This hall has since been demolished and replaced with the Student Services Building.

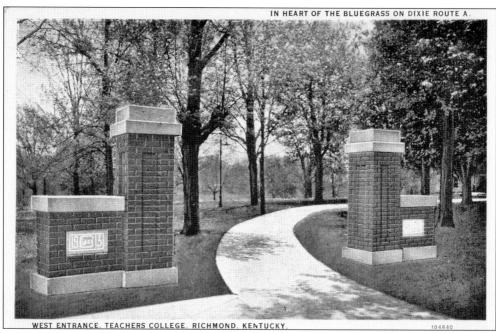

WEST ENTRANCE, TEACHERS COLLEGE, RICHMOND, KENTUCKY.

WEST ENTRANCE. This picture depicts the Lancaster Avenue entrance to Eastern Kentucky Teachers College. The brick entranceway can be credited to the classes of 1913 and 1914.

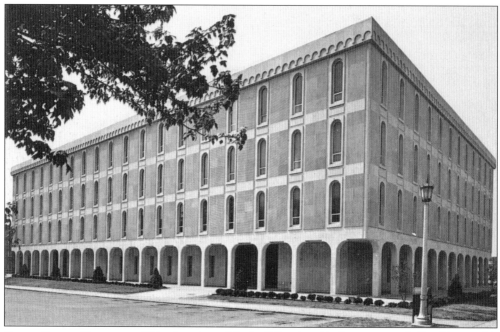

BERT COMBS BUILDING. This gleaming white building has 61 classrooms and 62 offices and is very functional. The building was named for Bert T. Combs, a former governor of Kentucky.

80

Four

BEREA

As Berea College grew, a surrounding community quickly sprang up. The college appointed a committee to look after the affairs of a newly developed town. They laid out streets and sold lots, established a fire department, dug a public well, and raised funds to have the railroad and public roads come through the town. In the spring of 1890, the retirement of President Fairchild and the selection of a new college president, William Stewart, created concern that the affairs of the town would be controlled by a man from outside the community. Using the strong political connection of Berea College professor LeVant Dodge, a group of Berea leaders acquired a city charter in a short period of time. On April 4, 1890, the town was incorporated and the affairs of town and college were separated for the first time. In nearly a century, Berea has had only four mayors: John Gay (1910–1957), Clint C. Hensely (1957–1981), Dr. Clifford Kerby (1981–2003), and Stephen Connelly (2003–present).

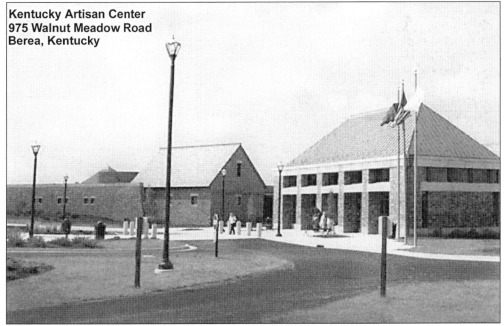

KENTUCKY ARTISAN CENTER OF BEREA. This showplace of Kentucky arts, crafts, and books was opened in 2003 on Walnut Meadow Road. It also houses a restaurant that features local cuisine.

BEREA GREETINGS. In 1913 it was common for almost every town to have a greeting card; Berea was no exception.

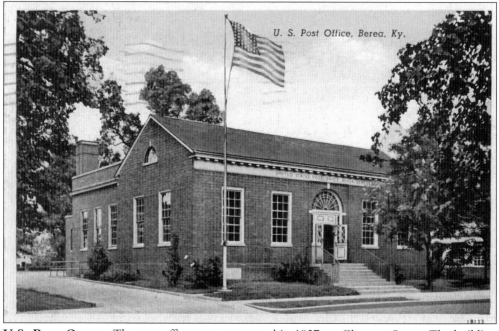

U.S. POST OFFICE. The post office was constructed in 1937 on Chestnut Street. The building is now used by the Berea Police Department. The post office relocated to a new facility on Walnut Meadow Road in 2000.

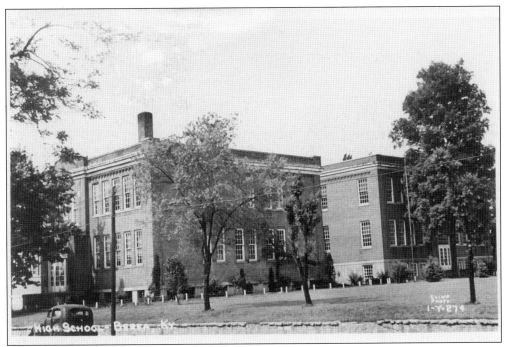

BEREA HIGH SCHOOL. The high school on the corner of Chestnut and Boone Streets was razed in 1969. The Berea Community Schools, an independent school district, moved to a new location at 1 Pirate Parkway. The car in the picture is from the 1930s.

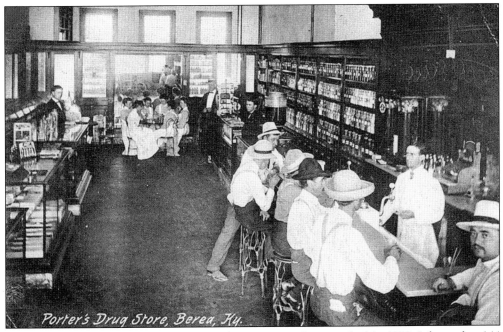

PORTER DRUG STORE. This drug store, shown in a card postmarked in 1908, is located at 144 Main Street. The drug store later became known as the Porter-Moore Drug Store. It is now the location of Berea Coffee and Tea.

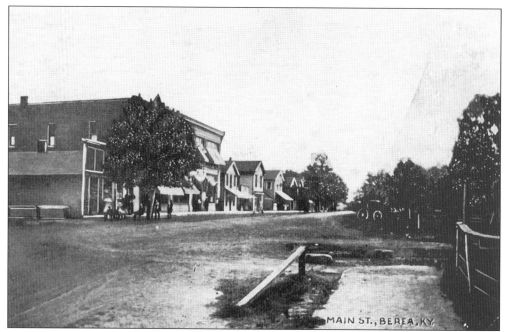

MAIN STREET. This card was published by Norwood Publishing Co. in Cincinnati and was printed in Germany. It shows Main Street before the street was paved.

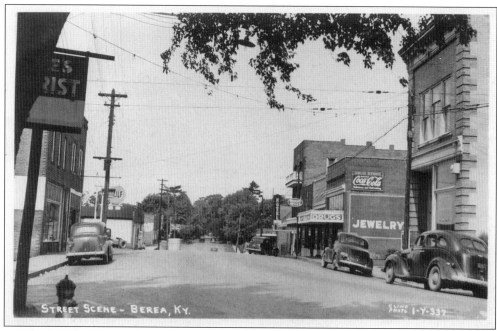

CHESTNUT STREET. This card, postmarked in 1949, shows the business section on Chestnut Street as it approaches Broadway over the L&N Railroad tunnel and proceeds south on U.S. 25.

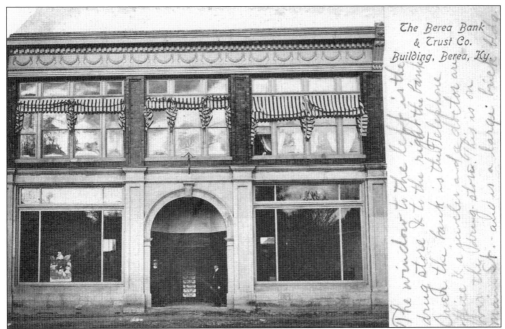

The Berea Bank
& Trust Co.
Building, Berea, Ky.

The window to the left is the drug store & to the right is the bank. Over the bank is the telephone office & a jeweler and a doctor are over the [drug] store. This is on main St. and is a large brick bl[ock].

BEREA BANK AND TRUST COMPANY. The pictured building is located at 32 Main Street. This particular view was postmarked in 1907. The written message describes the building: the window to the left is a drug store and the one to the right is the bank, a telephone office is located over the bank, and a jeweler and a doctor are located over the drug store. After the bank was closed, Garvice Kinkead, a Madison County native, opened the Peoples Bank at this location in 1970. Due to growth and lack of space, the bank moved to a new location. The present occupant, Appalachian Fireside Gallery, opened its doors in 1974. The bank vault with the lettering "Berea Bank and Trust Company" is still in this building.

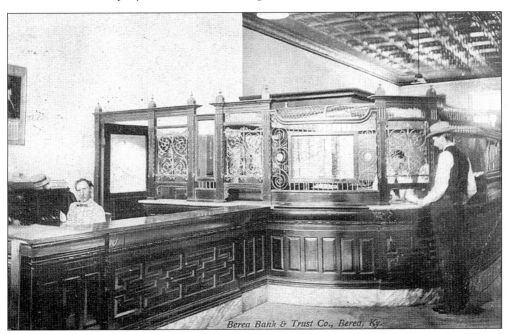

Berea Bank & Trust Co., Berea, Ky.

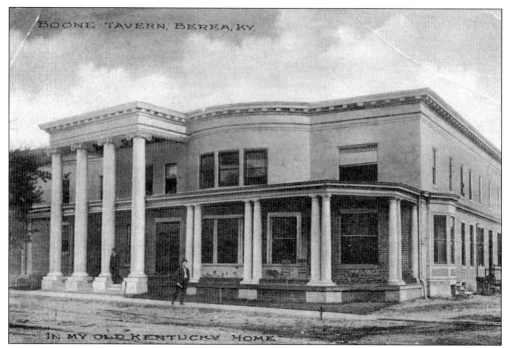

BOONE TAVERN. Prior to 1909, guests of Berea College were entertained in the home of the president. When the Boone Tavern opened, it had 25 rooms and a flat tin roof over its 2 stories. As early as 1910 there were plans to add a third story. Today it has grown to 58 rooms. College students work in all phases of the tavern's operation, and furnishings in the rooms were fashioned by Berea College Student Industries. The dining room's specialty is spoon bread; Berea even has an annual spoon bread festival. The hotel's fame has spread far and wide. Its guest list has included Eleanor Roosevelt, Henry Ford, Pearl Buck, Robert Maynard Hutchins, Charles F. Kettering, Jesse Stuart, and Thornton Wilder.

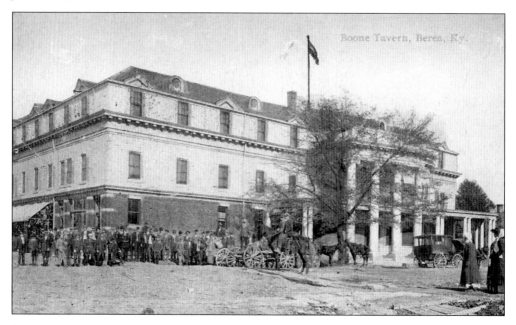

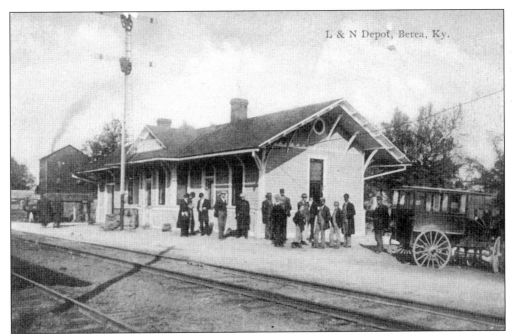

LOUISVILLE & NASHVILLE RAILROAD DEPOT. Berea is on the main line from Cincinnati going south from Richmond and into Tennessee. This depot was torn down and replaced in 1917.

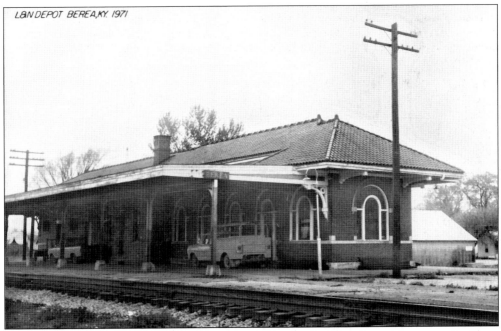

LOUISVILLE & NASHVILLE RAILROAD DEPOT. This brick station is now home to the Berea Tourism Center. L&N Days is an annual event that draws "old" railroaders from across the state. The last passenger service was in 1968.

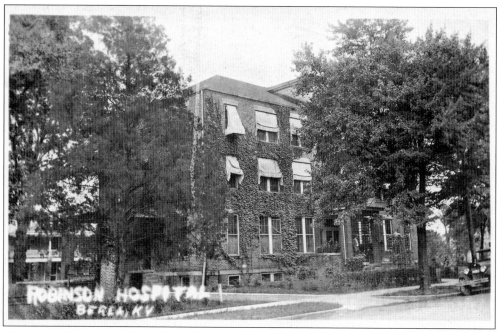

ROBINSON HOSPITAL. Located on Chestnut Street, this was once a private hospital.

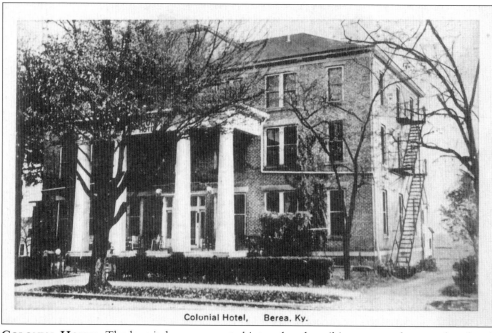

Colonial Hotel, Berea, Ky.

COLONIAL HOTEL. The hospital was converted into a hotel until it was torn down and replaced by a Hardee's restaurant. It is now a Mexican restaurant.

Five
BEREA COLLEGE

Berea College in Berea, Kentucky, is unique because of its student work program. Although the students receive low hourly compensation, they also receive free lodging and pay no tuition. Interestingly, when Henry Fairchild came from Oberlin College in Ohio to become Berea College's first president, he saw that a proper dormitory was urgently needed for young ladies. Ladies' Hall was built in 1870 at a cost of $50,000, and was named and modeled after Ladies' Hall at Oberlin. Bricks were burned in a brickyard just south of the site, and lumber (including butternut and chestnut) was prepared from adjoining forests. Fairchild was too modest to name the dormitory after himself; however, in 1937 (50 years after his death), the name was officially changed to Fairchild Hall. The building has been modernized with electricity and central heat, but the exterior remains much the same. Even the "widow's walk," similar to the one at Oberlin, remains intact on the northeast side of the roof.

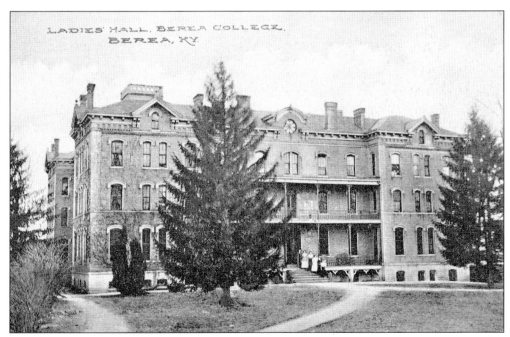

LADIES' HALL/FAIRCHILD HALL. Constructed in 1872, Ladies' Hall was the first brick edifice on the campus. In 1937, the name was changed to Fairchild Hall in honor of Henry Fairchild, the first president of Berea College.

Berea College, Berea, Kentucky.

Hello my friend! Thanks for your postcard. Am getting along O.K. and hope you are too. My "catarrh" is better as we have warm weather down here. How are you and Granville's

College Pennant Series No. 296. *(over)*

BEREA COLLEGE BANNER. This card was in the College Pennant Series; it was postmarked in 1908.

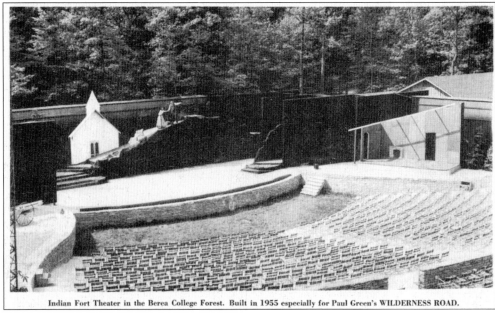

Indian Fort Theater in the Berea College Forest. Built in 1955 especially for Paul Green's WILDERNESS ROAD.

INDIAN FORT THEATER. This theater was built in 1955 in the forests of Berea College especially for the production of Paul Green' s drama *Wilderness Road*, the musical story of a mountain community during the Civil War.

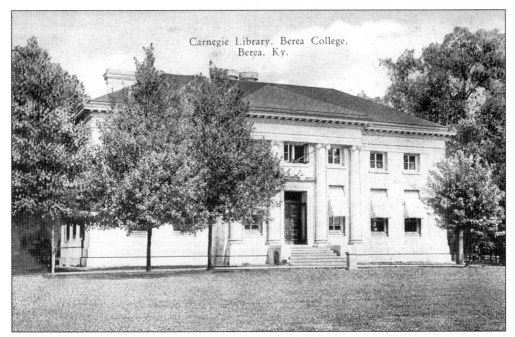

CARNEGIE LIBRARY. The library was built in 1905 with the stone portion donated by Andrew Carnegie. An addition was completed in 1935. It is now known as the Frost Building, named for Berea's third president and used as a classroom building.

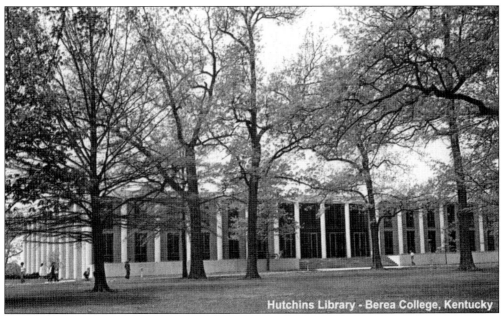

HUTCHINS LIBRARY. Built in 1966, the library was named for two former presidents: William J. Hutchins and Francis S. Hutchins. The building has room for 300,000 books and houses special collections of Appalachia as well as the college archives. A computer center was added in 1991.

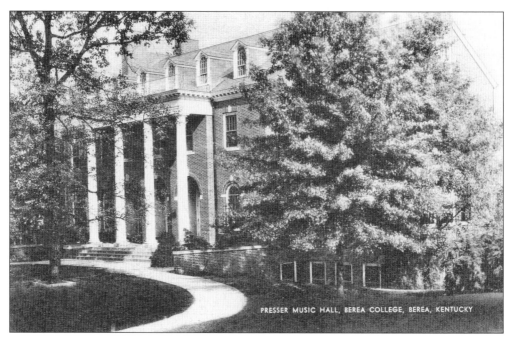

PRESSER MUSIC HALL, BEREA COLLEGE, BEREA, KENTUCKY

PRESSER HALL. Built in 1931 and named for the founder of *Etude* magazine, Theodore Presser, Presser Hall is the home of the music department. The beautiful Gray Auditorium, with its Howard E. Taylor Memorial Organ, is in the center of the building. Taylor was also the organist at the Union Church in Berea. Presser Hall's renovation was completed in the spring of 2004.

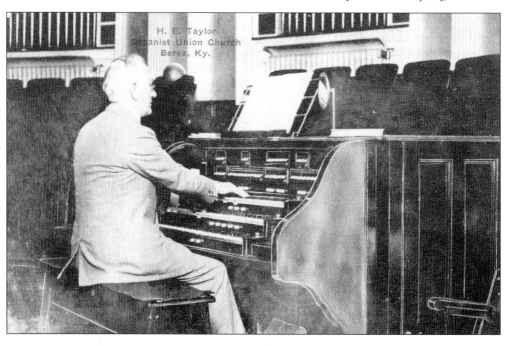

ALUMNI MEMORIAL BUILDING. This building houses conference rooms, the food services, a snack bar, the Baird Lounge, and the alumni association offices.

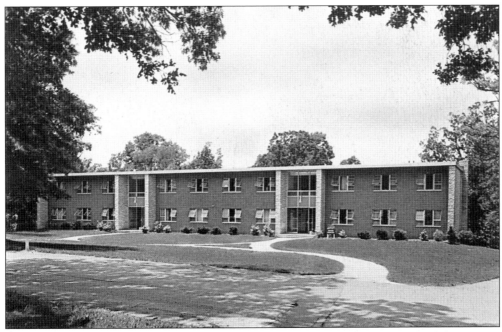

BINGHAM DORMITORY. Completed in 1960, this men's dormitory was a gift of the *Courier-Journal & Louisville Times* Foundation. It was named in honor of Judge Robert Worth Bingham, a former trustee of Berea College.

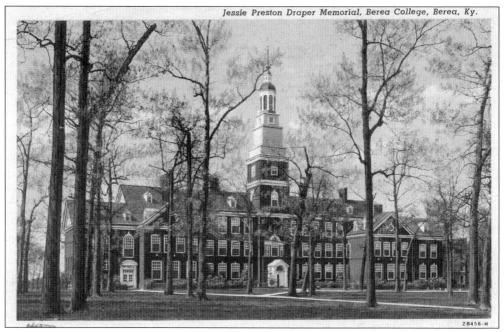

Jessie Preston Draper Memorial, Berea College, Berea, Ky.

JESSIE PRESTON DRAPER MEMORIAL BUILDING. Constructed in 1938 with funds from the Draper Foundation, it is modeled after Independence Hall in Philadelphia. It is the largest classroom on the Berea College campus.

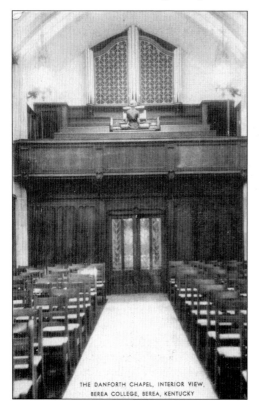

THE DANFORTH CHAPEL, INTERIOR VIEW, BEREA COLLEGE, BEREA, KENTUCKY

DANFORTH CHAPEL. The Danforth Chapel and the adjoining Fireside Room were the gift of William H. Danforth, a trustee of Berea College. The chapel is attached to the Jessie Preston Draper Memorial Building.

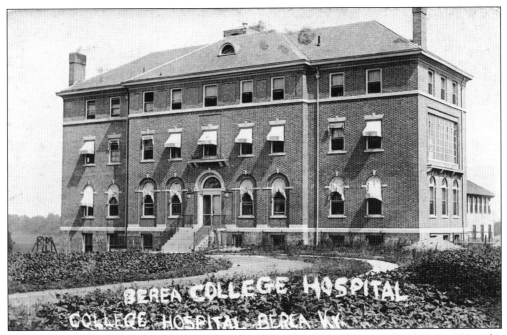

BEREA COLLEGE HOSPITAL. The hospital began as an eight-bed cottage in 1898. In 1917, the construction of a new hospital was undertaken on the present site. In 1967, the college gave both the hospital and the land to the Berea community as a non-profit hospital. It has undergone several additions and is now affiliated with the Catholic Health Initiatives.

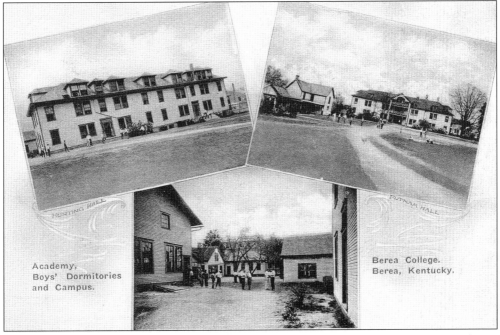

THREE EARLY BUILDINGS. Putnam Hall (upper left) and Hunting Hall (upper right) are shown with the Academy (secondary school). These buildings were all men's dormitories on the Berea College campus.

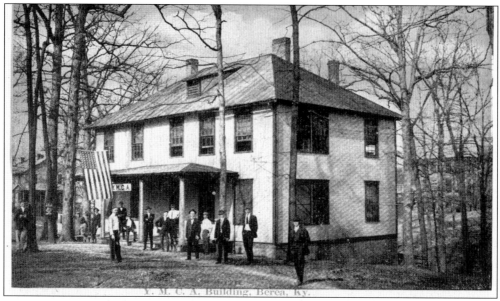

YMCA BUILDING. This frame building was once used by the Young Men's Christian Association for its activities. Like most other wooden structures—with the exception of the Rustic Cottage—it has since been destroyed.

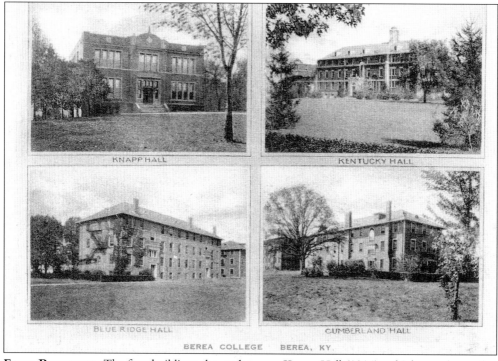

FOUR BUILDINGS. The four buildings shown here are Knapp Hall (1914), which was donated as a school for members of the faculty; Kentucky Hall (1917), which was named for the Commonwealth of Kentucky; Blue Ridge Hall (1917), which housed the Navy V-12 cadets who trained there during World War II; and Cumberland Hall.

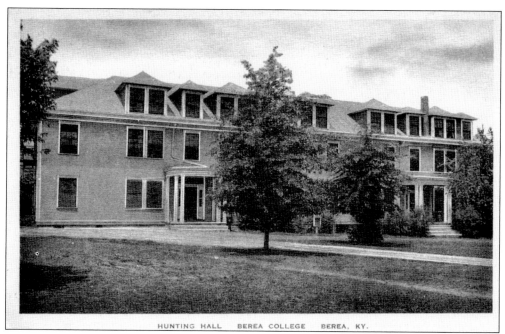

HUNTING HALL. This dormitory was built in 1915 by student labor in order to house 80 men. This frame structure, now demolished, originally cost $3,400 to build.

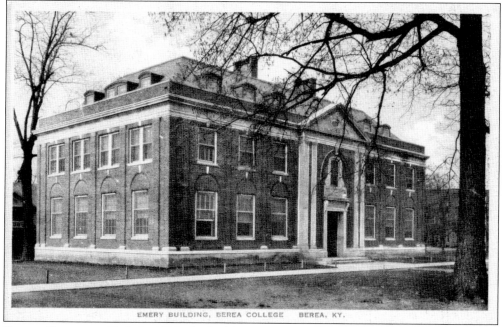

EMERY BUILDING. Built in 1925, the building was a gift from Mary E. Emery of Cincinnati. It is now the Home Economics Center.

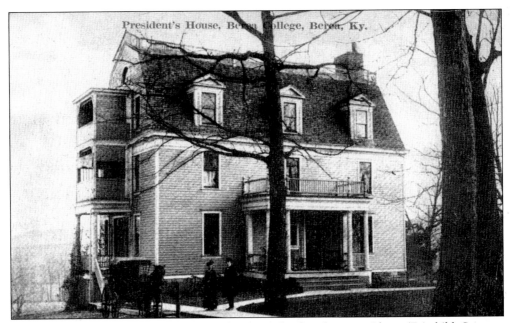

PRESIDENT'S HOME. This residence was home to the first three presidents (Fairchild, Stewart, and Frost) and part of the administration of William Hutchins. To make room for a new structure, this frame building was moved to Scaffold Cane Road and became Curtis House, a dormitory for men.

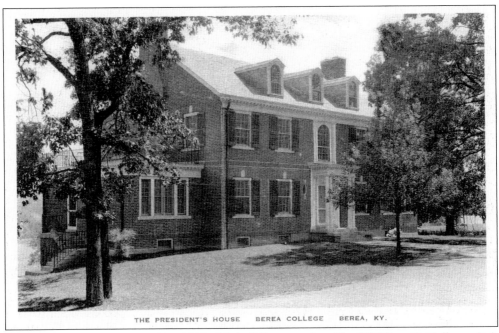

THE PRESIDENT'S HOUSE BEREA COLLEGE BEREA, KY.

PRESIDENT'S HOME. Erected in 1930, this building was the gift of William B. Belknay. It is furnished to a large extent with furniture made by students in the Berea College Woodcraft Shop.

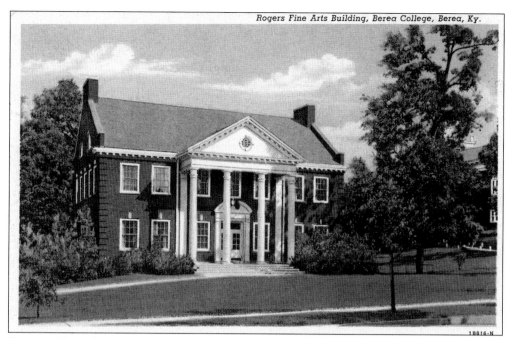

ROGERS FINE ARTS BUILDING. The older part of this building was erected in 1936 and was donated by J.R. Rogers in honor of his father John A. Rogers, the co-founder of Berea College. In 1977 a new wing (named for Mr. and Mrs. Melvin Taylor) was added. Medieval tapestries and ancient Greek pottery are among the valuable items found inside.

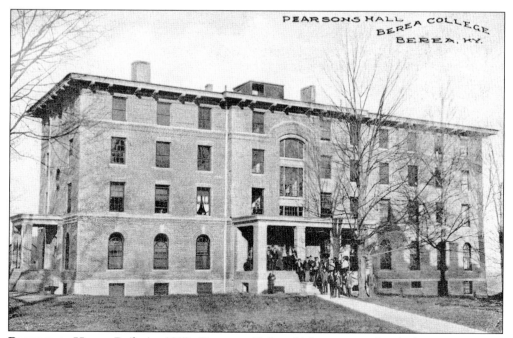

PEARSONS HALL. Built in 1910, Pearsons Hall, which accommodated about 150 young men, had a suite of 5 rooms for a resident professor as well as several private rooms for guests of the college.

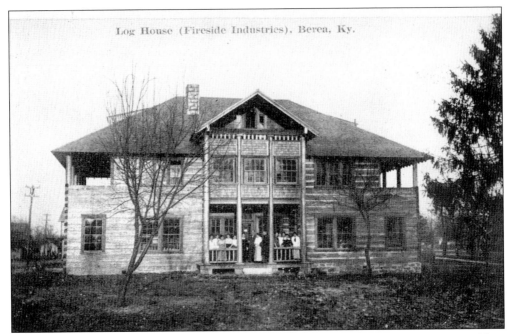

Log House (Fireside Industries), Berea, Ky.

FIRESIDE INDUSTRIES. On fund-raising trips to the Northeast in the 1890s, Berea president William Frost took traditional Appalachian coverlets to illustrate his presentation on mountain people and the college's mission. These coverlets had been brought in to Berea by some students in exchange for tuition. Perceiving that there was a national market for traditional crafts, Frost established the Berea College Fireside Industries to market homemade crafts. Quickly the college built a loom house for the developing program and hired a supervisor to train workers and maintain quality. Frost hoped that the production of crafts would enable mountain people to earn an income and still hold their traditional lifestyle. Berea, along with Asheville, North Carolina, became the center of the American Crafts Revival in the first part of the 20th century.

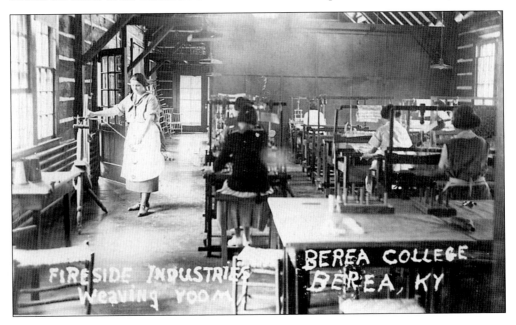

FIRESIDE INDUSTRIES Weaving Room BEREA COLLEGE BEREA, KY

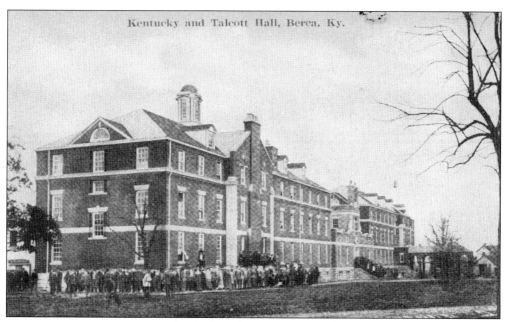

KENTUCKY AND TALCOTT HALLS. These two identical halls, conjoined at the center, were built in 1917. Talcott Hall is named for James Talcott of New York, who contributed a large portion of its cost. The other hall gets its name from the Commonwealth of Kentucky.

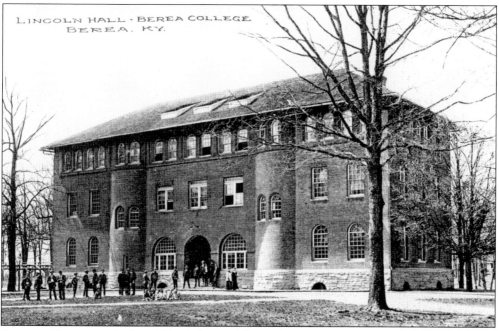

LINCOLN BUILDING. Built in 1887 and named for President Abraham Lincoln, this is the second-oldest building on the campus. The bricks were made in the college brickyard and the stone quarried by students. It was renovated after a floor collapsed. Now used as administrative offices, it has also been designated as a National Historic Landmark.

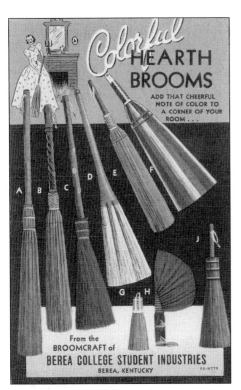

BEREA COLLEGE STUDENT INDUSTRIES.
Many different talents were utilized by Berea College students with the motto, "Made by students who earn while they learn." From the Broomcraft came a colorful selection of handmade hearth brooms in brightly dyed colors of corn and a variety of different handles.

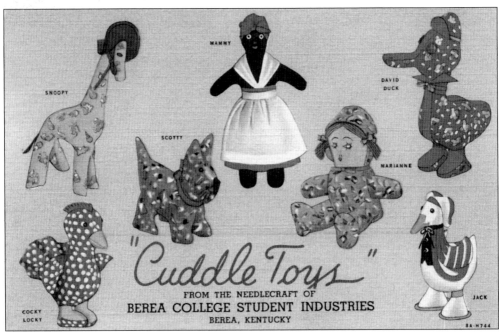

BEREA COLLEGE STUDENT INDUSTRIES. From the Needlecraft came a series of "cuddle toys" for children. Their quality of the toys was high enough to be commended by *Parents Magazine*. Choices of toy included Cocky Locky, Snoopy (not the one with which we are most familiar), Scotty, Mammy, David Duck, Marianne, and Jack.

BEREA COLLEGE STUDENT INDUSTRIES.
Hand woven by Berea College Student
Industries, these dainty little finger towels add
a quaint touch to the modern bathroom.
Emblems of various designs are laid in hand,
including those of Jack and Jill, Spinning
Wheel, Christmas Candle, Lincoln Cabin,
Thoroughbred, Scottie, Dutch Windmill,
Sailboat, and several others.

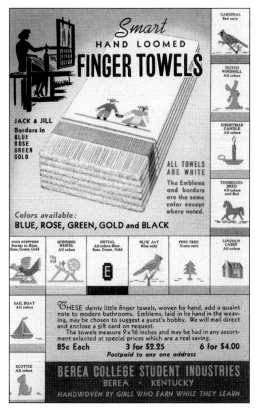

INDUSTRIAL AND VOCATIONAL BUILDINGS.
The Edwards Building on the left was
constructed in 1902 and named for Thomas
Edwards, a former dean. It was a college-
operated high school for many years. The
Bruce Building in the center houses the
Student Crafts offices, and the Trades
Building on the right is the location for the
Berea College Press and wrought iron shops.

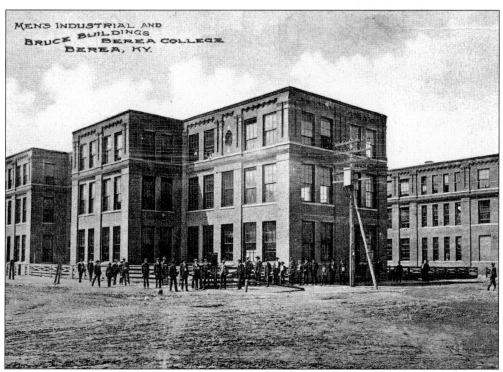

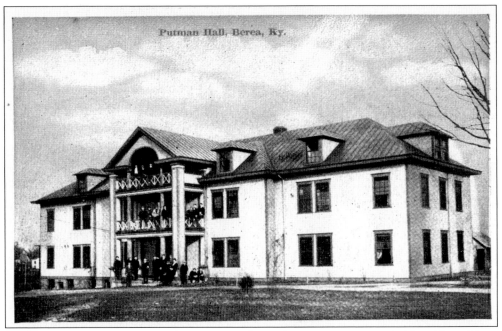

PUTNAM HALL. Built in 1913, this two-story frame dormitory was occupied by girls and later served as an academy for boys. It has since been demolished.

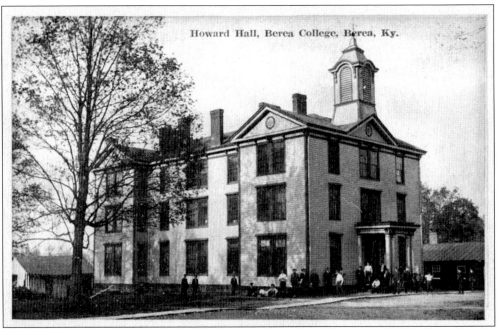

HOWARD HALL. Built in 1869, this building was named for Maj. Gen. Otis Howard, the commander of the 11th U.S. Corps during the Civil War battles of Chancellorsville and Gettysburg. Although the structure has since been leveled, the tower has been preserved and is in a flower garden area.

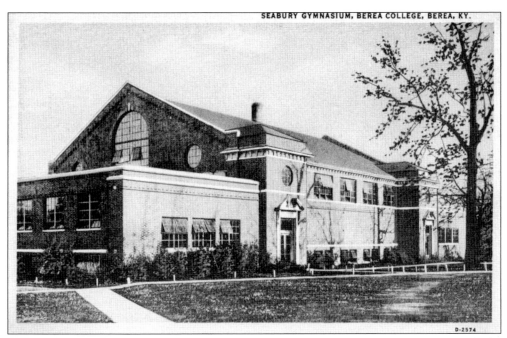

SEABURY GYMNASIUM, BEREA COLLEGE, BEREA, KY.

SEABURY GYMNASIUM. Built in 1928, the gymnasium was the gift of Mr. and Mrs. Charles Ward Seabury. Charles Seabury was a former trustee of the college. Until the new Seabury Center was opened in 1995, this gym was the home of the Berea Mountaineers basketball teams.

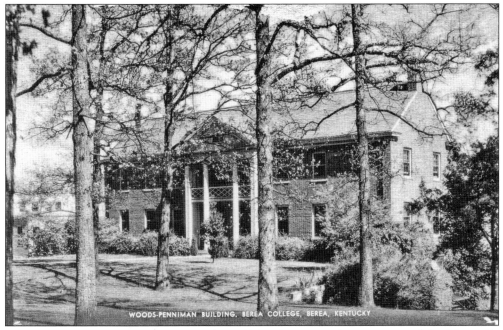

WOODS-PENNIMAN BUILDING, BEREA COLLEGE, BEREA, KENTUCKY

WOODS-PENNIMAN GYMNASIUM. Built in 1926, this gymnasium was named for Henry D. Woods, a man from Massachusetts who donated the money, and for Henry M. Penniman, a Berea staff member. In addition to hosting many community functions, it is the site of a week-long Christmas Country Dance School.

105

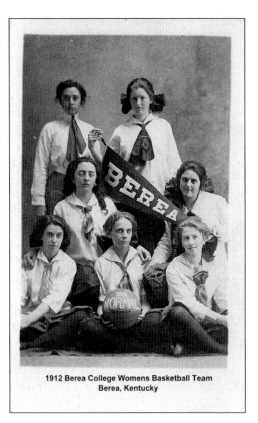

WOMEN'S BASKETBALL TEAM. These seven young ladies represented Berea College on the basketball floor in 1912. They look very pleased to be holding up the Berea College banner.

1912 Berea College Womens Basketball Team
Berea, Kentucky

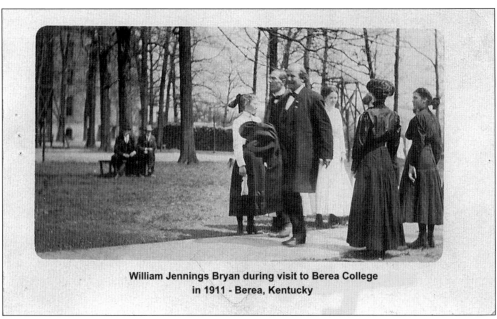

William Jennings Bryan during visit to Berea College
in 1911 - Berea, Kentucky

WILLIAM JENNINGS BRYAN. When William Jennings Bryan visited Berea College in 1911 he was photographed as he was walking on the sidewalk in front of President Frost's home.

SCIENCE BUILDING. Erected in 1928, the building is devoted to the sciences: physics, geology, biology, chemistry, mathematics, and astronomy.

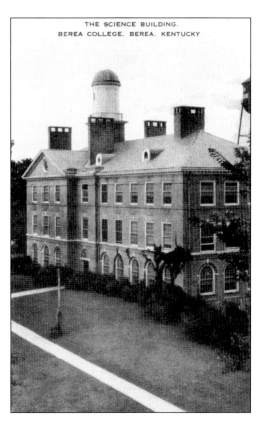

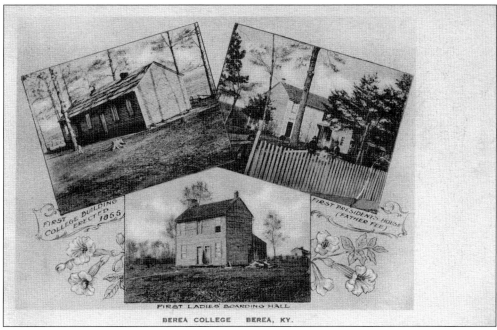

THREE FIRSTS AT BEREA COLLEGE. This card shows three firsts: the first college building (erected in 1855); the first president's home (Father Fee); and the first ladies' boarding hall.

BOONE TAVERN

BEREA COLLEGE —:— Berea, Kentucky
Modern Hotel — Colonial Atmosphere

◆

ROOM RATES: Daily

With Running Water	(Single)	$1.00-$1.75
	(Double)	$2.00-$3.00
With Private Bath	(Single)	$1.75-$2.50
	(Double)	$3.25-$5.00

ROOM RATES: Weekly
(Including Meals)

With Running Water	(Single)	$17.00-$19.00
	(Double)	$30.00-$35.00
With Private Bath	(Single)	$20.00-$30.00
	(Double)	$35.00-$45.00

MEALS:
Club Breakfasts 30c to 60c — Lunches 50c, 75c
Dinners 60c, 85c — Sunday Dinners 75c, $1.00

Special rates to families with children, also where more than two occupy the same room. In connection with the College student self-help program and the emphasis placed on the dignity of labor, no tipping is permitted.

◆

Write For Full Particulars

Richard T. Hougen,

MODERN HOTEL—COLONIAL ATMOSPHERE. This card depicts a schedule of rates for lodging and food at the Bonne Tavern Hotel. Weekly room rates for a double room with a private bath were $35 to $45 and included meals. Sunday dinners were 75¢ to $1. Tipping was not permitted. Richard T. Hougen was the manager.

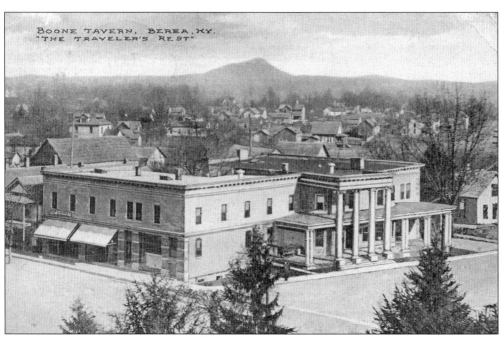

THE TRAVELER'S REST. Located on Main Street just off U.S. 25, Boone Tavern Hotel is operated by Berea College. About 80% of the hotel's staff are students. No tipping is a regulation that is strictly observed.

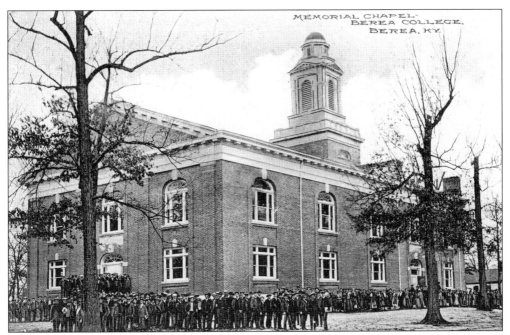

PHELPS STOKES MEMORIAL CHAPEL. After the frame chapel burned in 1902, Olivia Phelps Stokes offered to finance the building of a new chapel but stipulated that it must be constructed with student labor. The chapel was completed in 1906. In 1917 the domed tower was added, and in 1927 Stokes donated the chimes that still strike every quarter hour. This card was postmarked in 1910.

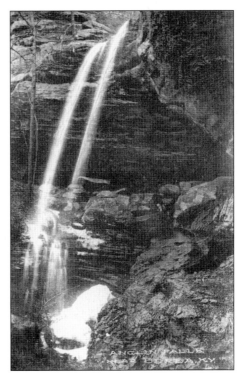

ANGLIN FALLS. This natural area, located in the John B. Stephenson Memorial Forest, was dedicated to the dream of the late president John B. Stephenson.

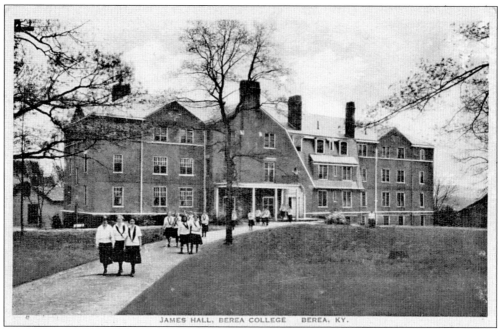

JAMES HALL. Built in 1918, James Hall is a residence hall for women.

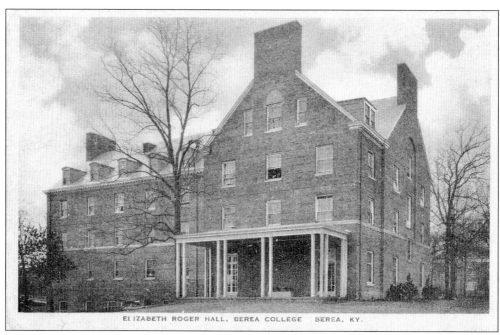

ELIZABETH ROGERS HALL. Erected in 1925, this hall was named for Elizabeth Embree Rogers, the wife of John A.R. Rogers. He was the first principal of Berea School and a member of Berea's board of trustees until his death in 1906.

Six

CHURCHES

The pioneer settlers coming into Kentucky raised churches to worship God. Early church buildings were crude structures that were hewn from logs and had split trees to serve as pews. Most early settlements were quick to erect a house of worship, general store, and post office. The mode of travel to these churches was horse and buggy, wagon, sled, or horseback. Many slaves were listed on the membership rolls in the early churches. Squire Boone performed the first wedding ceremony in the region in 1778. Soon frame buildings were replacing the log structures; they in turn gave way to bricks and stone. Many of the older churches made bricks on location. With the advent of the automobile, the lack of parking eventually became a problem. As a result, many churches moved to another location that would provide ample parking as well as a larger building for increased ministries for tots, teens, young adults, and seniors.

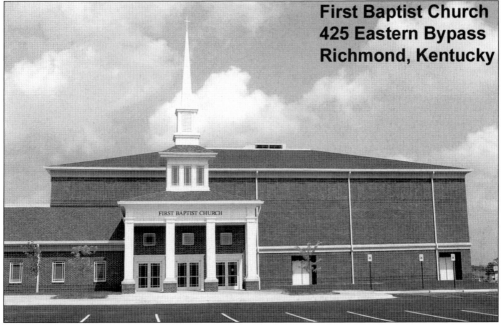

FIRST BAPTIST CHURCH. This new church sanctuary at 425 Eastern Bypass was dedicated on June 6, 2004.

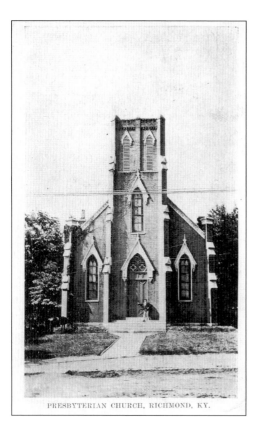

PRESBYTERIAN CHURCH, RICHMOND, KY.

FIRST PRESBYTERIAN CHURCH. The congregation of this church dates back to 1823. In 1828, the first building was a two-story brick structure and was the first church building ever erected in Richmond. The Masonic lodge occupied the upper floor, which was used until it was replaced by the building that was dedicated in March 1859. It was used until 1921.

FIRST PRESBYTERIAN CHURCH. The present house of worship was erected from 1920 to 1921 and was dedicated on May 15, 1921. The congregation observed its sesquicentennial in July 1977.

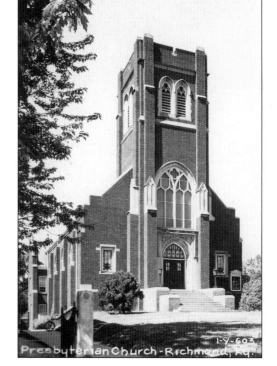

Presbyterian Church - Richmond, Ky.

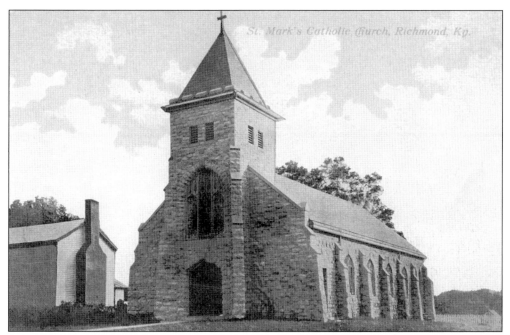

St. Mark's Catholic Church. St. Mark's was built in 1908 on the West Main Street site where two years prior a fire had destroyed the little mission church.

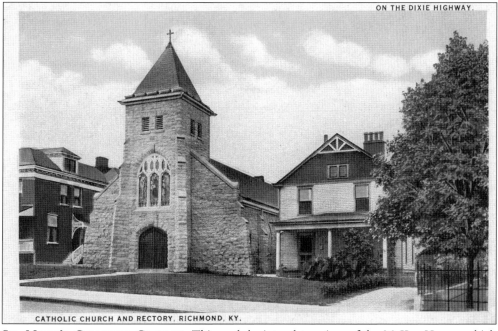

St. Mark's Catholic Church. This card depicts a later view of the McKee House, which is now the church office. Shown on the right is the pastoral residence that has since been torn down during an enlargement program.

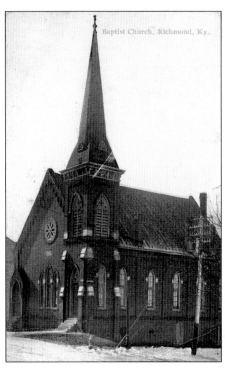

FIRST BAPTIST CHURCH. The congregation of this church dates back to 1828. In 1830, their first house of worship was a wooden structure. This photo shows their second building, which was erected in 1884 and used until 1923.

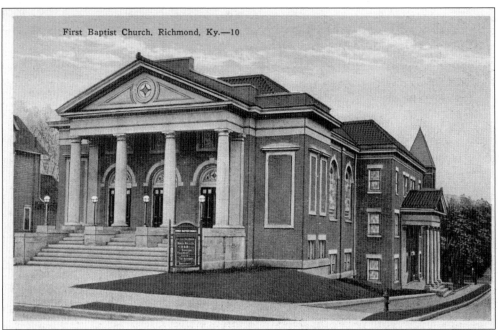

FIRST BAPTIST CHURCH. The third house of worship built for the First Baptist Church was constructed on the same site on Main Street and Lancaster Avenue. It was dedicated on May 11, 1924. An educational annex was added in 1965, and in 1971 a major remodeling doubled the seating capacity of the sanctuary. The congregation met in the new sanctuary at 425 Eastern Bypass on Sunday, June 6, 2004.

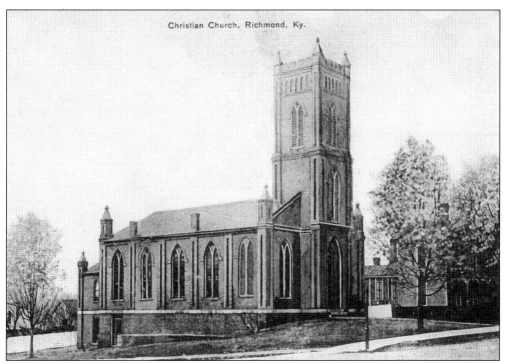

FIRST CHRISTIAN CHURCH. This house of worship has been located at the corner of Main Street and Lancaster Avenue since 1843 and has withstood the loss of three buildings by fires. The structure that was lost in 1912 has been replaced by two more recent buildings.

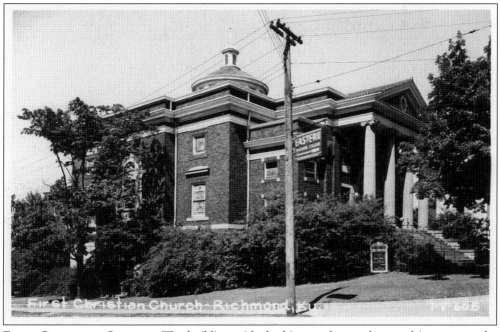

FIRST CHRISTIAN CHURCH. The building with the big cupola was destroyed in a spectacular blaze on August 4, 1959. The present sanctuary was dedicated on December 2, 1962.

115

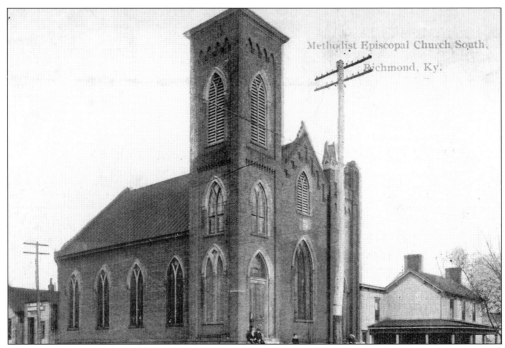

FIRST UNITED METHODIST CHURCH. Located at the corner of North Second and Irvine Streets, this church, organized in 1833, built its first structure on this site in 1841. The small frame structure was replaced in 1882 by this brick building and used until 1927, when the congregation moved to "church corner" on Main and Church Streets. It is now used by a commercial business.

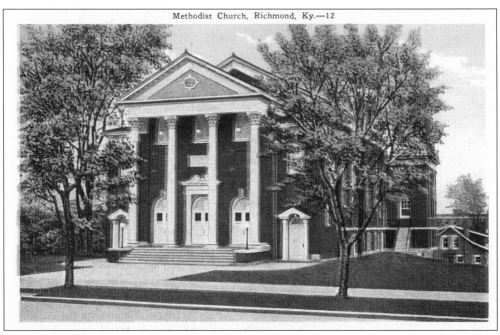

FIRST UNITED METHODIST CHURCH. The present building on West Main Street at the corner of Church Street was erected in 1927. An educational annex was added in 1991.

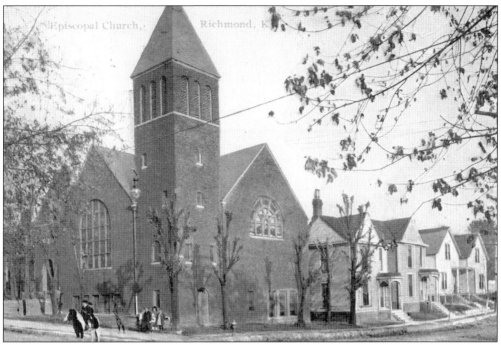

CHRIST CHURCH, EPISCOPAL. Built in 1887, it was the oldest church building in use in Richmond before the congregation moved to another location and sold it to the Richmond Area Arts Council. The stained glass windows in the church were preserved.

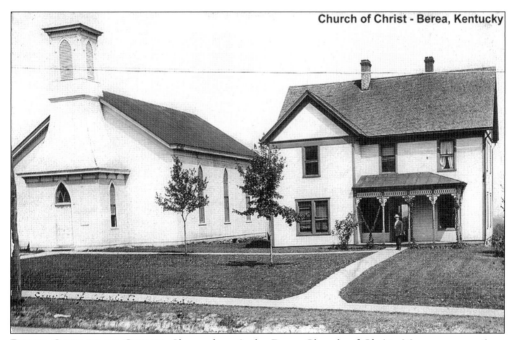

BEREA CHURCH OF CHRIST. Shown here is the Berea Church of Christ. Many congregations used former residences for their house of worship.

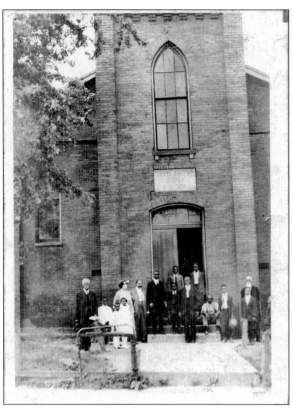

FIRST BAPTIST CHURCH, FRANCIS STREET. A group of African Americans organized this congregation in 1843 and built a log church. A second church made of brick was eventually outgrown and the third building, shown in this picture, was constructed in 1874 at a cost of $9,000. The structure was replaced in 1920 and used until 1995. It featured some beautiful stained glass windows, which were preserved for the new building. (Courtesy of George and Vickie Miller.)

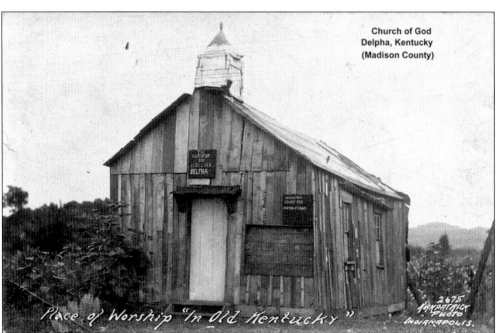

Church of God
Delpha, Kentucky
(Madison County)

Place of Worship "In Old Kentucky"

DELPHA CHURCH OF GOD. This church was located in Delpha in the northwestern section of Madison County. The structure is typical of many of the early churches in Madison County.

SECOND PRESBYTERIAN CHURCH. This church was built in 1884 on East Main near B Street as a result of sympathy for the North following the Civil War. Due to inactivity the building was razed in 1939. A Kroger store was later constructed there.

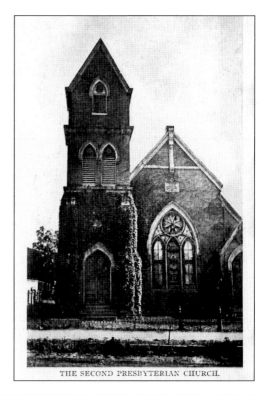

THE SECOND PRESBYTERIAN CHURCH.

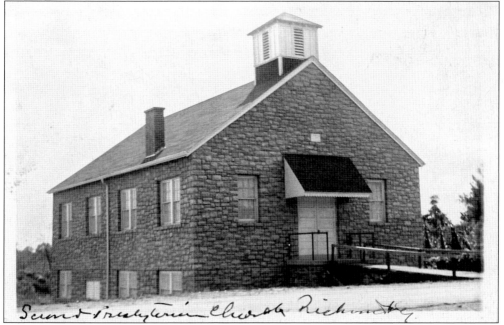

SECOND PRESBYTERIAN CHURCH. After the Main Street property was sold, a stone church was built on Estill Avenue. After that building was leveled, the site became the property of the City of Richmond. The Betty Miller Building, a community facility, has just been opened on the property.

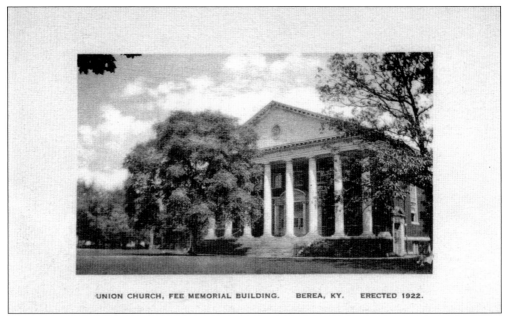

UNION CHURCH, FEE MEMORIAL BUILDING. BEREA, KY. ERECTED 1922.

UNION CHURCH, BEREA. Founded in 1853 by the Reverend John G. Fee, the church, like the college, is non-sectarian. It was one of the first churches in the South to include both blacks and whites in its congregation. The first meeting house used by the Union Church was constructed from logs. The present building was completed in 1922.

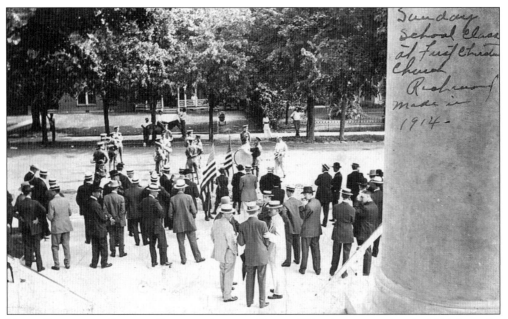

FIRST CHRISTIAN CHURCH SUNDAY SCHOOL CLASS. This photo was taken in 1914 from the top of the steps entering the building that was later destroyed by fire in 1959. The house across Main Street has been replaced and is now the First United Methodist Church.

Seven
HISTORICAL COVERS

Because Madison County was founded in 1786 and has now observed its bicentennial, it was fitting that this event and some other significant anniversaries be remembered with a historical cover. A cover is an envelope with a cachet marking the event and postmarked on the appropriate date at the nearest post office. In addition to Madison County, other places that have observed bicentennials include the City of Richmond, Tates Creek Association of Baptist Churches, Tates Creek Baptist Church, and the Viney Fork Baptist Church. Institutions that have observed centennials include the City of Berea, the Pattie A. Clay Regional Medical Center, First Baptist Church, First Christian Church, First Presbyterian Church, and Silver Creek Baptist Church.

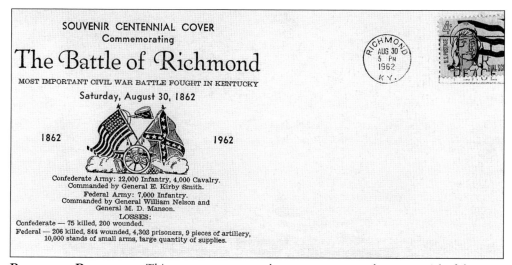

BATTLE OF RICHMOND. This cover was prepared to commemorate the centennial of the most decisive Confederate victory in Kentucky in the Civil War. The card is postmarked on August 30, 1962, exactly 100 years after the battle.

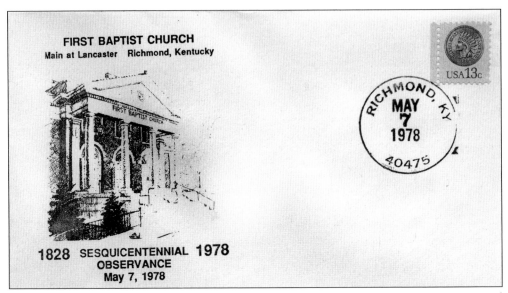

FIRST BAPTIST CHURCH. This cover was prepared to commemorate the sesquicentennial observance of the church on May 7, 1978. The church has been in existence since 1828.

TATES CREEK ASSOCIATION. This cover was prepared to commemorate the bicentennial of the Tates Creek Baptist Association. Tates Creek is part of the Kentucky Baptist Convention and Southern Baptist Convention. Its postmark was November 23, 1993.

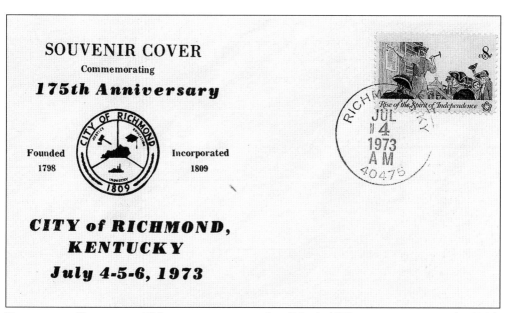

RICHMOND, KENTUCKY. This cover was prepared on July 4, 1973, to commemorate the 175th anniversary of the City of Richmond. The city was founded 1798 and incorporated 1809. This card was postmarked on July 4, 1973.

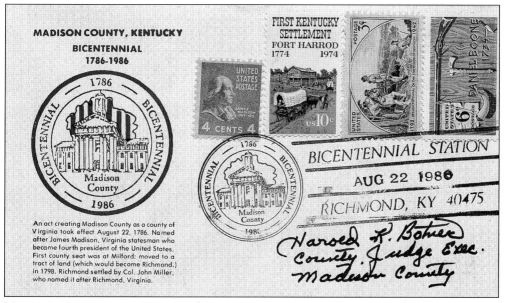

MADISON COUNTY, KENTUCKY. This cover was prepared and postmarked August 22, 1986, to commemorate the bicentennial of Madison County. The postage stamps used on this cover were the 4¢ Madison stamp (for whom county was named); the First Kentucky Settlement stamp; the 3¢ sesquicentennial of the statehood of Kentucky stamp (1942); and the 6¢ Daniel Boone stamp (1968).

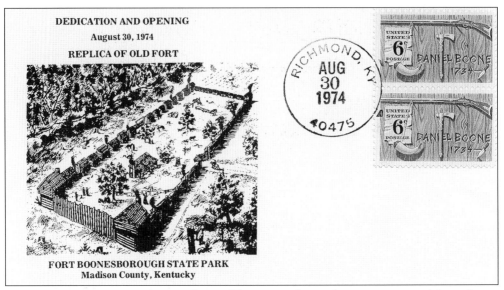

FORT BOONESBOROUGH STATE PARK. The cover shown here was prepared in order to commemorate the dedication and opening of a replica of the fort at Boonesborough on August 30, 1974.

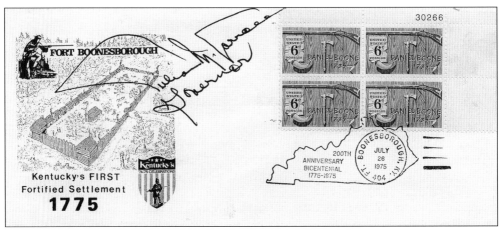

FORT BOONESBOROUGH BICENTENNIAL. This cover was prepared to commemorate the bicentennial of Kentucky's first fortified settlement in 1975. It was signed by Gov. Julian Carroll and postmarked with a special Fort Boonesborough Bicentennial cancellation on July 26, 1975.

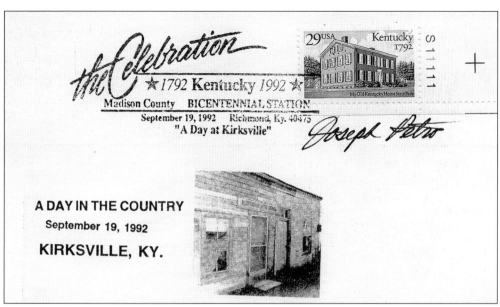

A Day at Kirksville. This cover was prepared to commemorate "A Day at Kirksville" on September 19, 1992. The photo is of old post office. It was signed by Joseph Petro, the designer of the Kentucky bicentennial stamp.

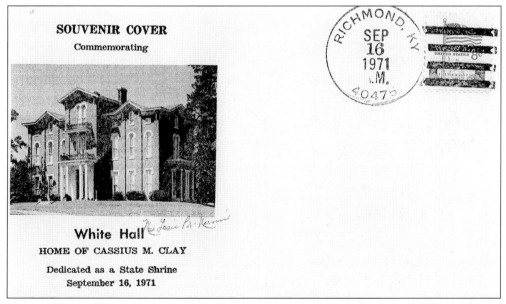

White Hall. This cover was prepared to commemorate the dedication of White Hall, the home of Cassius M. Clay, as a state shrine on September 16, 1971. The cover was signed by Kentucky's first lady and a leader in preserving the site, Mrs. Louie (Beula) Nunn.

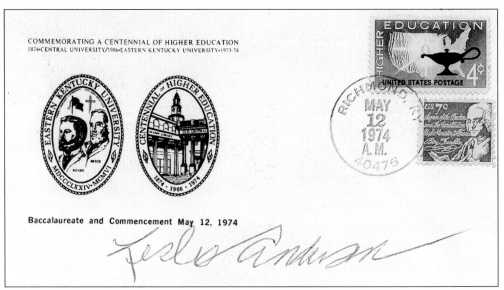

EASTERN KENTUCKY UNIVERSITY. The cover shown was prepared in order to commemorate a centennial of higher education (1874–1974) on the Richmond campus. The card was signed by Leslie Anderson, Eastern's first graduate. It has a postmark of May 12, 1974.

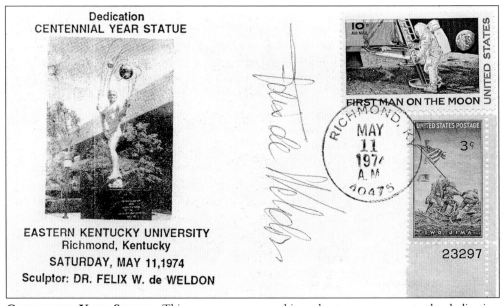

CENTENNIAL YEAR STATUE. This cover was prepared in order to commemorate the dedication of the Centennial Year Statue. It was signed by Sculptor Felix deWeldon, who also sculpted the Iwo Jima statue in Washington, D.C., and postmarked on May 11, 1974.

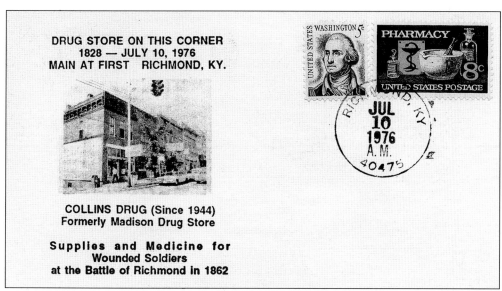

COLLINS DRUG STORE. The cover shown here was prepared to commemorate a drug store on the corner of Main and First Streets. The drug store had been in operation for 147 years, from 1828 to 1976. Operating then as Madison Drug Store, it furnished supplies and medicine for wounded soldiers in the Battle of Richmond in 1862. This cover was postmarked on July 10, 1976.

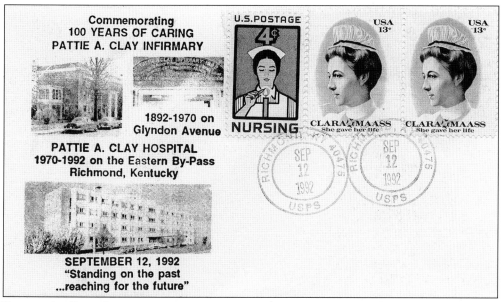

PATTIE A. CLAY INFIRMARY AND HOSPITAL. This cover was created to commemorate 100 years of caring, from 1892 to 1992. Both the old and new buildings are shown in this card, which was postmarked on September 12, 1992.

BATTLE OF LITTLE BIGHORN. The cover shown here was prepared to commemorate Kentucky's Medal of Honor recipients, including two from Madison County, in the Battle of Little Bighorn (June 25–26, 1878). The ceremony took place on June 26, 1999. This card was postmarked with special cancellation.

HOWARD COLYER FIELD. This cover was prepared to commemorate the dedication of Howard Colyer Field at the Richmond-Berea Madison Airport. The dedicatory address was given by Edward T. (Ned) Breathitt, the governor of Kentucky from 1963 to 1967. Signatures are by Howard Colyer, chairman of the airport board, and all other board members. The cover was postmarked on October 25, 1982.